Chichester

MURDERS & MISDEMEANOURS

Chichester
MURDERS &
MISDEMEANOURS

Philip MacDougall

AMBERLEY

First published 2009

Amberley Publishing
Cirencester Road, Chalford,
Stroud, Gloucestershire, GL6 8PE

www.amberleybooks.com

Copyright © Philip MacDougall

The right of Philip MacDougall to be identified as the Author
of this work has been asserted in accordance with the
Copyrights, Designs and Patents Act 1988.

British Library Cataloguing in Publication Data.
A catalogue record for this book is available from the British Library.

ISBN 978 1 84868 208 5
Typesetting and Origination byAmberley Publishing
Printed in Great Britain

CONTENTS

INTRODUCTION

In taking a look at some past crimes that have taken place in and around the Chichester area, it has also been possible to trace local developments in the detection and prevention of crime. In focusing upon several high profile murders, it has been possible to show the investigative methods used, while also dwelling upon a number of serious flaws that prevented a satisfactory outcome.

For much of the period covered by this book, those responsible for law and order, both within the city and its immediate surroundings, were a force for the prevention of crime rather than for the detection of felons. When a major crime did take place, there were no police officers with the required experience to lead an intensive investigation. For this reason, it was necessary to call upon those outside the area who did have this expertise. As often as not, this meant that either Bow Street Runners (established as an organised force by Henry Fielding in 1748) or members of the Metropolitan Police (formed in 1829) would be asked to give assistance.

As well as offering expertise, the Metropolitan Police had the advantage of being of considerable numerical strength, allowing officers to be loaned out for the policing of large events. In the 1860s, the rural West Sussex constabulary would frequently seek the help of the 'Met' when it came to ensuring that the annual Goodwood races were relatively crime free. With hundreds of Londoners descending on the event, it was also to be assumed that members of the 'big smoke' underworld, especially hoardes of 'finger smiths', would join them. While the local constabulary, operating out of Chichester and Petworth, had the manpower to patrol the main stands they were of insufficient number to cover outlying areas of the course. Instead, this additional security was provided by teams of officers from London, these same individuals bringing with them knowledge of the faces upon which a careful eye should be kept. In later years, with the Metropolitan Police having established a forensic

laboratory in Hendon it was the practice to send evidence there for testing.

Incidentally, the word 'finger smith' is a colloquial term of the period for a pickpocket. Where such colloquial terms have been used in the text, a note as to their meaning can be found at the end of the book. It is also within these same chapter notes that information as to sources and other connected items may be found.

In the writing of this book I would like to acknowledge and give my thanks to Stephanie, my partner, who has provided endless cups of coffee, given help in research and acted as proof reader.

Philip MacDougall, Ph.D
February 2009

THE MORNING DROP

Early on the morning of Monday 26 October 1818 it is said that over 10,000 people assembled in the Broyle. It was a number well in excess of the city's population, the event they were about to witness attracting sightseers from as far away as Portsmouth and the fashionable resort town of Brighthelmstone. Within Chichester itself, and at precisely 10 o'clock, a number of local dignitaries began to make their way in procession along East Street and in the direction of the sixteenth-century Market Cross.

At the head of this slowly moving cavalcade were Thomas Hodge and William Brooks, high constables with responsibilities for protecting the city against criminals. In their immediate wake came the entire force of daytime constables with a number of 'specials' who had been sworn in for the occasion. Somewhere towards the centre of the column was a horse-drawn cart in which was seated the bailiff, a further high-ranking city official. Next to the bailiff was a somewhat scruffy and dejected individual who pointedly looked away from the many on-lookers who lined the roadside.

Moving at a necessarily slow and funereal pace, those at the head of the column turned into North Street. Above the noise of the crowd, many of whom were jeering, could also be heard the tolling of the cathedral bells. From more distant areas too, including the Pallant and St Martin's, the bells of the numerous churches within the city were added to this raucous mid-morning cacophony.

It was the dirty and scruffy individual seated next to the bailiff whom the assembled onlookers had come to see. A Brown Bess, or private, he was a long serving infantryman in the Orange Lilies, the nickname given to the 35th Sussex Regiment of Foot. Unusually pale and insipid, he was being brought to the Broyle for execution. That 10,000 or more were awaiting his arrival was a result of this being a public execution – a morning drop – and a sight that had not been seen in this part of Sussex for a good many years.

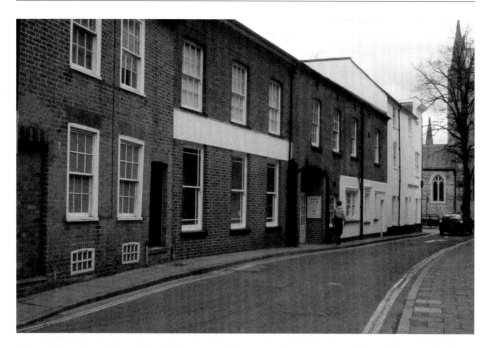

Upper West Lane (now Chapel Street) at the point where Private John Holloway of the Orange Lilies struck and killed Thomas Parr of the 9th Lancers.

Among those eager to see the stretching of Private John Holloway was, most probably, Hannah Chase. A feisty young woman from the town, she was frequently to be found in the company of soldiers. While having no particular occupation, she was certainly adept at encouraging these lobster boys, named because of the colour of their jackets, to shed in her direction some of the spare coins that jangled in their pockets. Among her various acquaintances had been that very same John Holloway for whose arrival the crowd were impatiently awaiting. But they were far from being close – far from it. From beginning to end, their relationship had spanned the length of just one particularly hot and sultry evening towards the end of August.

Town doxies and bored redcoats were a volatile mix and nowhere more so than in the overcrowded garrison town of Chichester. Since the end of the war with Boney, the government had not the slightest notion of what to do with its fighting men. With no likely war on the horizon, all that was possible was to reduce their numbers and unleash the rest on any unsuspecting municipality. For Chichester, this meant making full use of the barracks that had been built a few decades earlier in the Broyle while cramming the rest into any available rooms that could be found in the town.

Of particular value for the housing of these soldiers were the fifty or so inns, hostelries and taps that thrived either within or immediately outside the city walls. But in making use of such establishments, it placed these same soldiers within easy reach of some of those town girls whose morals were as low as the River Lavant during that year's unusually hot summer. It was a problem faced by most other military towns of the period, the majority having more women among their regular townspeople than could naturally be expected. Conversely, the local villages in the countryside that surrounded them seemed unusually short of young women. The molls of many a nearby hamlet having strangely developed a desire to find work in the neighbourhood of soldiers. While not all of them sold themselves as determinedly as the young Hannah Chase, a goodly number were there to make what they could out of any greenhorn lobster.

For the authorities of Chichester, in the form of the elected Corporation, this cocktail of soldiers and their would-be molls, was a problem of no small proportion. Increasing amounts of money collected from ratepayers had to be directed to financing a daytime force of constables who were supported by the night watchmen of the evening. The task of the latter, in particular, involved clearing the streets of drunkards, all suspicious persons and the increasing number of newly-arrived town daughters who prowled the central streets of the city during the hours after twilight.

Not that Cicestrians had always viewed the soldiers lodged upon them with complete distaste. At the time when Boney had threatened invasion they had been much fêted. Following the comprehensive victory of Waterloo, intense celebrations had been held throughout the city. Within every inn and tap house, lowly privates, corporals and sergeants had found themselves in receipt of numerous free drinks. As for their officers, they had been invited to various formal balls and lavish banquets held at the assembly rooms, council chambers and more fashionable houses.

That was three years ago. Since then, the relationship between citizenry and military had changed. No longer were the men who wore the red coat quite so welcome. In fact, the city's polite society had now come to consider them a highly disagreeable nuisance. Swaggering through the streets, cursing and blinding, their drunken behaviour was a mainspring of daily upsets. Many began to question their very presence, wishing to know why, if they had to be in Chichester, they could just not be totally constrained to those expensive barracks that stood over a mile from the city centre.

Admittedly this was a solution – but far from realistic. A simple equation: there were over 2,000 soldiers now residing in Chichester but the barracks on the Broyle had space for only 1,400. The rest were thrown on the town,

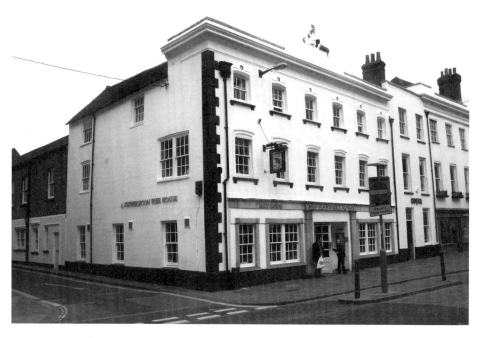

The Anchor (now part of the Dolphin & Anchor) is the section of building nearest to the camera. In a courtyard behind (with a separate entrance) was located the tap house.

soldiers of the 9th Lancers together with the light bobs, or infantrymen of the 31st and 35th regiments were mainly housed in those low class hostelries that gave them immediate access to knock-me-down ale and scheming molls.

One of these taps was in a courtyard immediately behind the Anchor coach house in West Street. While the city's esteemed citizenry and their respected guests supped in the palatial surrounds of the three-storey coach house that fronted the main street, the less well-to-do were restricted to a much dingier two-storey wooden building that stood behind the main building. Approached from Upper West Lane (now Chapel Street), it was suitably far back from the main building to ensure that the affluent visitors to the coach house need never encounter those who could only afford the tap. Serving as landlord or, in the language of the day, the ale draper, of both establishments was William Combes. Recently he had had thrust upon him a dozen light bobs of the Orange Lilies. Consisting of eleven Brown Besses and a corporal, they were all quartered in a single upstairs room immediately above the tap. With little else to attract them, these comrades in arms would, each evening, while away the hours with numerous drams until befuddled and top heavy. In this, they were encouraged by the unusually hot weather. Throughout August local

temperatures had been so high that it had reminded some of the Orange Lily old toasts of the days they had spent fighting under the blistering sun of a number of Mediterranean islands.

The evening of the 21st was no different from any of those earlier evenings in August. While a few of those billeted in the upstairs room of the Anchor tap remained in their quarters playing cards, the majority were downstairs smoking their sot weed and imbibing ale. Among them were two of the regiment's Irish recruits, the soon to be stretched Private Holloway and his messmate Private John Daly. Like all Irishmen, they had the gift of the gab – it commonly said that simple immersion into Dublin's River Shannon was enough to cure anyone of bashfulness. These two broganiers had also been joined by more light bobs and a further two Brown Besses of the 31st, this the Huntingdon Regiment of Foot. Adding some spice was the presence of a mischievous young wench by the name of Hannah Chase. Through the bleary eyes of drink and the haze of tobacco smoke she seemed the epitome of every man's dream. Dressed up like a Bartholomew's baby, all of the light bobs knew her to be as common as a barber's chair. Yet they yearned her company, for even in Chichester where such women abounded, young soldiers were much in the majority. In this situation, none could have failed to notice her low cut bodice, heaving breasts and the occasional bead of perspiration that trickled invitingly towards her top hamper. As her mug was drained all were eager to offer her a refill. However, it was to Holloway that this honour most frequently fell, the man being on a promise that she would spend some time with him later that evening.

And into this mix stepped two more Brown Besses, this time from the 9th Lancers. To those of the 35th they were flash sods; horsemen whose fine cut uniforms were so much more splendid than that of the lowly infantrymen. However, they seemed fairly placid lads, so the Orange Lilies accepted their company.

As for Hannah, the only moll present, she was decidedly in favour of accepting these new recruits into their midst. Re-seating herself next to Thomas Parr, one of the new arrivals, she made it quite clear that any advances, military or otherwise, he chose to make upon her meagre defences would result in an immediate surrender. In turn, he carried out his own military reconnaissance, noting the shape and contour of what men of the day referred to as her 'apple dumplin shop'. Unbeknown to Holloway, her legs began to entwine those of the newcomer while their hands frequently touched. Above decks, the assembled company continued to joke and make much of their recent wartime experiences. Holloway, decidedly drunk, stepped outside for a moment to relieve himself. Of this, Parr took advantage and whispered a few words into the ear of the ever-adventurous girl, asking if she would prefer to go with him. To this she simply nodded her assent.

As the evening wore on, an increasing number of those from the 35th began to drift upstairs, most of them as drunk as wheelbarrows. Eventually, Holloway, who could hold his drink more than most, also joined his wilting colleagues. Firmly anchored to his arm was the young moll whom they had all so recently met. Either she had forgotten her promise to the lancer or was too drunk to resist the demands of the Irish infantryman. Within the tap, this now left only Thomas Parr and his fellow lancer together with a remaining remnant of the 31st. They continued to drink, with Parr convinced that the wanton wench would soon return and partner him a rogering gig that he believed he had been promised. To speed matters along, he approached the stairs that led to where the men of the 35th were billeted. 'Oh, Miss Laycock, I hold you to your promise,' but he received no reply. Again, but this time even louder, he called out, 'leave the Paddy and join me you young wench'. Unbeknown to Parr, these loudly spoken demands were having an affect. Hannah began moving to the door, showing every indication as to her intentions. The Irish private immediately pulled her back. 'You're promised to me and I'm thinking a blanket hornpipe,' making clear his intentions. Others of the 35th decided to support their fellow comrade and agreed to sort out Parr and any others who remained in the tap. Making their way downstairs, a fight soon broke out. It was a fairly limited bout however, merely involving one of Holloway's messmates and the remaining thirty-firster, with both the lancers wisely keeping their distance. 'I'll lump your jolly nob for you,' threatened the man from the 35th as he aimed a punch towards the other's head. 'I'll make an Irish beauty of you,' came the equally boisterous response, the declaration making it clear that he intended giving his opponent two black eyes.

Following a few telling blows on each other, the two decided to call it a day both returning to their respective corners. That the private from the 35th had a bloody nose, possibly suggested to those who were watching, as to who it might be deemed had won that short bout. In the meantime, William Combes, the ale draper, had gone to fetch the night watchman. He knew from past experience that the night might not yet be over, it being possible that a renewed fight might well begin at any moment. As it happens, this looked most unlikely, the two sides beginning to disperse. Even Parr prepared to return to his own billet, and would have done so if Holloway, still in close company with Hannah Chase, had not appeared at the top of the stairs.

'You damned bog lander,' yelled the aggrieved lancer. To this he added a number of stronger epithets, questioning whether Holloway was the son of a bachelor. This, inevitably, could lead in only one direction. The insulted Irish light bob decided to settle matters once and for all. Taking the stairs two at a

*A soldier in the uniform of the 35th, the
regiment in which Holloway was serving at the
time of the murder.*

time, he soon drew himself level with Parr and proceeded to smash his fist into
the side of Parr's face. It was, however, a one sided affair with Parr, overcome
by drink, making no attempt to resist. Hannah, according to her own later
testimony given in court, warned Parr to be off and pushed him through the
passageway that led out of the courtyard and on to Upper West Lane.

'Stand to arms,' called out the billet corporal of the 35th. It was a strange
and unexpected command, requiring all those in the upstairs billet to take
their muskets and prepare for an immediate attack. The corporal might have
been better employed in ordering the others to restrain Holloway. At least this
would have prevented Holloway from grabbing his own musket and running
after the now retreating lancer. 'So you scamper off, you coward,' Holloway
yelled. 'I'm going to give you such a basting that you'll soon be facing Old Mr
Grimm.'

By now, Holloway had a dual motive for this second attack on Parr. Not
only had the lancer tried to steal his wench but the man who had sided with
him had bloodied one of the Orange Lilies – to Holloway, in his befuddled
state, this required vengeance to the extreme.

'You are one of the villains,' Holloway called out. 'And no mercy will I show you.' Parr had run a mere 40 yds along Upper West Lane when Holloway caught up with him. Drawing the ramrod out of the barrel, he smashed the musket down on the back of Parr's head. The lancer, now floored, was quite defenceless as the musket once again crashed down.

'Have mercy,' cried the fallen man. 'Have mercy.' Eventually Holloway desisted, believing the lancer to be finished. As he walked away, he looked back to admire his handiwork. Parr, whose injuries might have been survivable at this point, looked up and groaned.

'God damn his eyes, he is not dead yet,' Holloway was heard to shout. Retracing his last few steps he once again brought the musket down upon his victim, this time holding the stock with both hands to ensure greater force. His messmate Daly, who had seen what was happening, sped forward to try and save the fallen man, but was unsuccessful in his intervention. 'Get out of my way,' Holloway yelled. 'But if you don't, then you'll get the same as him.'

One more time he brought the musket down, this time making contact with the lancer's skull. This was the blow that killed him. A dull thud maybe, but of such force it broke the musket, the stock falling away from the butt. Only then did Holloway choose to take notice of Daly, the two of them beginning to walk away together.

While, just a few minutes earlier the lane running alongside the tap had been deserted, this was no longer so. With the commotion having attracted a good deal of attention, a few local folk began to venture out of their homes. In particular, John Gorsuch, whose room looked directly down on the scene, later admitted during Holloway's trial that he had seen everything. But, frightened out of his wits, he had made no effort to intervene. Instead, he stood back from his window, not wishing to be seen.

On returning to the Anchor, a foolish attempt was made to conceal Holloway's part in the crime. Possibly the billet corporal, not fully realising the truly hideous nature of the crime that had taken place, told both Daly and Holloway not to say a word of what had happened. As for the broken musket, he promised that he would tell the colonel of the regiment that this had been done while on duty.

In the meantime, William Combes had been successful in his search for the night watchman and brought him to the passageway that led into the courtyard where the tap was situated. Glancing along Upper West Lane, both quickly realised that events had taken a serious turn for the worse. Rushing to where a small crowd had assembled they found, lying in a pool of blood, the lifeless body of Private Thomas Parr.

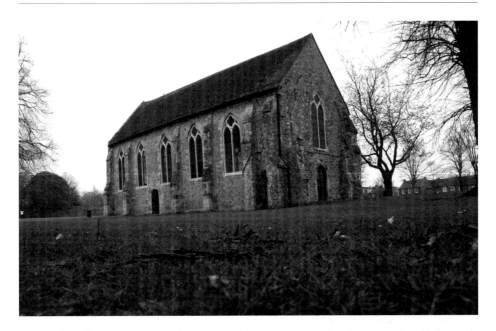

The Guildhall in Priory Park where John Holloway was tried and sentenced to be hanged.

'I saw everything,' the shocked Gorsuch now felt brave enough to declare. 'It were two soldiers who did it. One of them wouldn't stop. Time after time he brought that musket thing down on that poor man's head.' 'Two soldiers you say,' offered the night watchman. 'Go on, tell me more.' 'Mercy, Mercy, he called out. But the big one with an Irish accent just wouldn't stop.' Gorsuch continued. 'Then, when he was quite sure he was dead, the murdering beast disappeared off. He went into the Anchor tap. He's still there if you want to arrest him.'

Doubtless an arrest was the night watchman's intention, but the risk was high. After all, there were a lot of soldiers around and they could always turn on him. But what choice did he have? His written instructions, and to which he had agreed on taking up the appointment were quite clear, he was to bring to the city gaol at East Gate, 'all malefactors, disturbers of the King's Peace and all suspicious persons, night walkers and persons misbehaving themselves.' Clearly, someone had misbehaved himself, and that someone must meet his certain appointment with the acorn tree.

Without hesitation he proceeded back along Upper West Lane to the Anchor tap and demanded that the soldier responsible for the attack be handed over. By this stage, even the billet corporal realised all was up. There was no way he could carry on protecting the foolish Holloway. Indeed, he even helped the

An interior view of the Guildhall as it appeared at the time of the trial.

constable, providing a military escort to march Holloway to the lock-up.

At no point could Holloway have doubted the outcome of his trial at the Chichester and County Quarter Sessions that took place some two months later. Held in the Guildhall, a large and roomy building standing within open grounds on the north-east side of the city, he was accused of wilful murder. Hannah Chase, John Daly and John Gorsuch all gave reasonably honest accounts of what had taken place. In addition, Francis Guy, a surgeon, was called. Shortly after the murder he had carried out a brief autopsy and from that felt able to conclude that Thomas Parr had died from a fatal blow to the brain. He further enlightened those in the courtroom that this fatal blow might well have resulted from Parr having been hit by the butt end of a musket.

A jury of twelve duly listened to the evidence and within fifteen minutes had reached their conclusion. Upon their return the deputy recorder, William Johnson, stepped forward and looked directly at the foreman of the jury. 'How do you find the prisoner, guilty or not guilty?' 'Guilty,' came the response.

All eyes now turned upon John Steele, the recorder. It was up to him to pronounce the sentence. The crowded courtroom was hushed into silence as all strained to catch his every word. 'Private John Holloway,' he began. 'You have been found guilty of a most terrible crime and for which there can be only

JOHN HOLLOWAY,

Who was Tried at the Sessions for the City of Chichester, on Friday the 23d of October, 1818, before J. Powell, Esq. Mayor, E. V. Utterson, Esq. Recorder, J. Murray, Esq. S. Cobby, Esq. and T. Rhoades, Esq. Magistrates and W. Johnson, Esq. Deputy Recorder, for the Wilful

MURDER

Of Thomas Parr, Private of the 9th Lancers.

HANNAH CHASE deposed, that she was drinking at the Anchor Tap, with Holloway, Parr, another lancer, and a man of the 35th, on the evening of the 21st of August. She went into the soldiers room, over the Tap, with Holloway and others. In about ten minutes Parr called her to come out; when the prisoner and the deceased had a quarrel respecting which of the two she should go with, the lancer or Holloway, having promised the latter. The noise they made brought others of the 31st from their room, and a battle was fought in the street, between one of the 31st and the man of the 35th, as he had taken part with the two Lancers. This terminated in favour of the latter.—On coming into the yard, Parr said something to Holloway, which she did not hear; upon which the prisoner struck the deceased several times with his fist on the head. Parr endeavoured to get away, the prisoner following and beating him all the time.—(Parr was much in liquor; Holloway was sober.) During this scuffle the Corporal called to his men, " to stand to their arms;" did not know why, as the deceased made no resistance. (The prisoner afterwards explained this, by stating that the two Lancers and the man of the 35th had fallen upon him.) On hearing this, and the Corporal having gone into the soldiers room, she advised Parr to make off, as his comrade and the 35th man were gone. He could only get about forty yards down the street, when the prisoner overtook him with a musket, and drawing the ramrod out, he beat him with it until he broke it ; and then with the muzzle end of the musket. Parr repeatedly begged for mercy. It was moonlight, and she was within six or seven yards the whole time. Prisoner now left the deceased a short distance, but seeing him lift his head up and groan, he exclaimed, " ―― his eyes, he is not dead yet." She then walked away down the street, as she saw another man coming from the Anchor Tap, but a few yards from the prisoner. Did not see him strike with the butt end. Returned after some time, as a young man told her he was dead. The watchmen and others were there then.

JOHN DALY deposed, that hearing a quarrel in the Tap-room, he came down with others, he stated the circumstance of the battle the same as last witness, after which he returned to his room and went to bed, heard the corporal call out " stand to arms," did not know why, no one obeyed the call ; the prisoner then came up the ladder into their room and took up his firelock, had a candle in the room, he

knew it was his, and therefore put on his clothes and followed him down into the street, where he saw him strike the deceased with the small end of it. Holloway looked round on leaving the deceased and hearing him groan, exclaimed, " ―― his eyes, he is not dead yet," and then struck him on the head with the but-end holding his musket with both his hands ; witness begged him to desist, but prisoner threatened to serve him the same if he interfered, upon which he went back to his quarters, the corporal followed in about five minutes, and the witness then took his musket from the prisoner and told him the stock was broken, what should he do ; corporal told him not to mention it, and that when he got back to the regiment he would tell the colonel it was done on duty.

WILLIAM COMBES (landlord of the Anchor Inn) deposed, that he was alarmed by the cry of " Murder," apparently on the premises, while in his bar, and immediately went into his yard, (the Tap being detached and let off) he returned through the house into the street, where he saw two men running, whom he supposed to be soldiers, one knocked the other down, and he then went to alarm the watchman ; on his return he saw some one go into the Tap-room passage and believes closed the door : saw the deceased lying on the ground, the blood running from his mouth, but could not see any wound at that time ; felt for his stock which was gone, and his shirt colar was undone, at this time the watchmen and others arrived.

Mr. F. GUY, Surgeon, proved the nature of the wounds, and gave it as his opinion that the fatal one was a concussion on the brain, which might be caused by a blow from the butt end of a musket. Here the evidence for the prosecution closed.

JOHN GORSUCH (called by the prisoner's Counsel) deposed, he was alarmed by a noise in the street, and looking through the window, saw two soldiers, one of whom had a musket in his hand. Heard the deceased begging very hard for mercy, and heard one of them distinctly say, " You are one of the villains, and no mercy will I shew you."—Saw the man who had not the musket turn, as if speaking to the one who had, when he turned round, and struck several violent blows, with the butt end of the piece, on his head. They then both walked for about five yards, and then ran away. Did not open the window till the watchmen and others arrived, when he told them it was two soldiers who had done it, and that they were gone into the Anchor Tap.

The broadsheet hawked around Chichester immediately after John Holloway's execution and which supposedly carried the condemned man's last words. (West Wessex Archives Office Add Ms 29710)

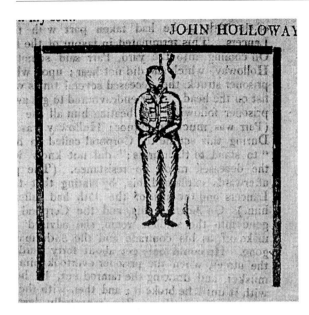

A supposed depiction, as carried by the same broadsheet, of John Holloway's appointment with 'the drop'. (West Wessex Archives Office Add Ms 29710)

one sentence. In two days hence, you will be taken to a place of execution and you will be hanged by the neck until you are dead.' Holloway visibly wilted. Throughout the trial he had nervously moved from one foot to the other, finding it difficult to stand still. Now, he simply fell forward, his head falling into his arms. 'Upon being cut down,' the recorder continued. 'Your body will be taken by surgeons for dissection. Once the surgeons have finished with the body I give my consent for burial.'

This was not as unusual as it might sound. It was quite common practice for those executed to have their bodies examined, it being one of the few legal means by which surgeons could learn about the inner organs. It was noted by the *Sussex Advertiser* that Holloway was particularly distressed by the knowledge that his body was not to be immediately interred. The newspaper, however, had shown no sympathy, informing its readers of its surmise that Holloway had 'without a similar sense of feeling, witnessed the cutting up of hundreds with the sword, on the plains of Waterloo'.

On the morning of his execution, Holloway awoke at three, quite unable to sleep. In a tearful state, he was still far from coming to terms with what was about to take place. Nominally a Catholic, he sought the last rites, these administered by two military chaplains called over from the barracks. Time, from then on, passed slowly for Holloway. He found it difficult to eat breakfast and occasionally started talking to his gaolers, but often seemed incoherent. Brought out from his cell for his appointment

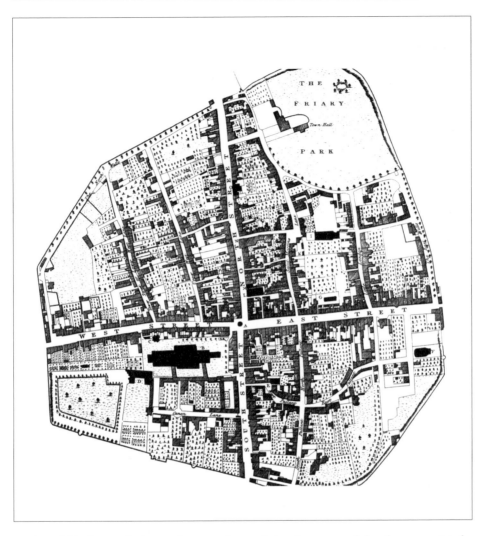

A plan of Chichester, dating to the year 1812 and showing many of the places associated with the final months in the life of Private Holloway. The Guildhall in Priory Park (Friary Park on this map) is located in the north-east quadrant of the city, while the Anchor is immediately opposite the cathedral.

with the acorn tree at exactly 10 o'clock, he was quickly handed over to the custody of the Bailiff.

'I now commit the unhappy culprit into your hands,' the town gaoler, John Humphrey, began to recite. 'This, in order that the just and awful sentence of the court may be put into execution. And may the almighty God have mercy on his soul.'

Having passed through the streets of Chichester, the cart finally reached the Broyle about one hour later. Carefully, the driver of the cart positioned it next to a tall and strong oak that had been specially marked out for the occasion. One of its overhanging branches had a rope slung across it, one end secured to its massive trunk and the other formed into a noose. The public executioner had prepared all of this, it being part of his formal duties and for which he traditionally received the Judas sum of thirteen pence for each man successfully collared. An unnamed individual, he had already checked both the weight of the man to be hanged and the strength of the tree.

Some dispute exists as to whether Holloway uttered any last dying words before the noose was placed around his head and the Orange Lily Brown Bess launched into eternity. If he did utter any words, then they would doubtless have been short and very simple, a request that God might forgive him. A few moments later the signal was given and the cart would slowly have moved forward, the noose gradually tightening around the light bob's neck. As it did so, Holloway tumbled from the rear of the cart and began to swing in the fashion of a clock pendulum. Unfortunately for the condemned man, this method of hanging was out-dated and ever so slightly barbaric. The momentum of a short fall from the back of a cart was insufficient to bring about an immediate demise, Holloway taking several minutes before he finally choked to death.

The body was now returned to the city on that same cart that had brought to the acorn tree that same living specimen. It was headed for the Council House in North Street where a number of keen and enthusiastic surgeons had assembled. Over the next few hours they cut and prodded, searching for various organs that could be later dissected and examined. For them, the death of Private Thomas Parr was a godsend. Once re-sewn, patched and re-clothed, the body had one further appointment prior to interment. It was to be publicly displayed – another gruesome feature of early nineteenth-century life. For two days, therefore, anyone wishing to confirm for themselves that the Irish light bob had paid the full penalty for his act, only need go to the Council House where it was open day for all.

At the Anchor tap, where Holloway's former comrades may well have gathered on the evening of the execution, one at least may have brought with him a copy of the libellous broadsheet that claimed to have the final words of their now deceased messmate.

'Well m'lads, let's drink to the one who is no more,' might well have declared John Daly in his relentless Irish brogue. 'A moment, before we do,' another might have said. 'Let me read those last words he spoke on the gallows.' 'Well, do so. None of us were allowed to attend' was John Daly's possible

response. 'They thought we might try to release him. So, yes, read his words.'

'I acknowledge the justice of my sentence, and am come my dear fellow beings to atone for my crimes against society by the sacrifice of my life. Of life alas! When the sprightliness of youth and the glow of health, when my strength of body and vigour of mind, render my continuance among you desirable beyond all that language can express.'

'Oh never. Never, are these his words. What fools do they think we are that they think we'd believe this rubbish?' Daly might have said. 'We'll hear them out, but we know that these are not his words nor his way of saying things. Continue, but don't believe.'

'But the dread sentence is irrevocably past, and the moment of my departure is at hand,' continued their fellow messmate. 'Before death then shall have closed these weeping eyes and I am forbidden any longer to behold the light of the sun, hear, I beseech you, what I have to say.'

'So what has he got to say, oh do continue my good man,' would have come at least one sarcastic intervention. 'It is the only good I can now do you, it is my last tribute to an offended God. Know then, that all my sinful courses began in breaking the Sabbath: to this baneful source I attribute all my misfortunes, to this accursed cause I owe it, that I now address you under every mark of infamy, and every feeling of horror. If you would then avoid my fate, beware that you follow not my example. Learn to meet God in his ordinances, reverence his most holy day, neglect not those duties by which piety is animated, by which virtue is strengthened, by which grace is obtained; by which in short, that spiritual armour is acquired and preserved, which will enable everyone of you to withstand in the evil day, and having done all to stand. And I hope the Lord Jesus Christ will have mercy on my soul.'

'A bouncer, nothing but a great lie,' might have come a further voice. 'But let us at least drink to the man and hope that Christ, indeed, will have mercy on his soul.'

'BECKY, I ALWAYS LOVED YOU'

Westbourne, which, as the crow flies, lies about nine miles west of Chichester, has never been a village especially noted for crime. Yes, like any other village, it had those who had been tempted to step over the line. Indeed, some crimes, such as poaching and smuggling, were seen as socially acceptable. Everyone benefited and nobody seemed to be the loser. In a village that was – during the nineteenth century – primarily made up of agricultural labourers, attitudes towards law breaking were often influenced by a rise and fall in agricultural prices. In times of extreme penury, the labourers of the village might choose to strike out at the richer farmers, determined to use this as a means of improving their everyday lot.

The early 1830s was one such difficult period. It was a time of falling wages, increasing costs and rising unemployment. Many younger families had been forced to leave the village while the elderly had little that they could look forward to. It was a picture replicated throughout much of southern England, with agricultural labourers placing the blame on greedy farmers and their increasing use of mechanical devices that were taking the place of human labour.

The peak year of discontent was 1830. During the late autumn a number of Westbourne farm labourers organised themselves into a committee that oversaw several nocturnal forays. Not only did they destroy several machines on the Sussex side of the border, but they also joined with those in Hampshire and struck out at a number of Emsworth farmers. Sometimes they issued letters of warning, while at other times they simply destroyed the offending machinery and disappeared under the cover of darkness. In Westbourne, they felt particularly confident, destroying one newly purchased threshing machine as it stood in the central square of the village.

When acts of such extensive law breaking took place, the authorities relied upon the army to step in and arrest the perpetrators. In that year, with farm labourers taking similar action across the whole of southern England, over

1,000 arrests were eventually made with about half this number sentenced to transportation. Given the ferocity of these punishments, it was clear that local landholders had been greatly shocked by the actions of their employees. On the other hand, knowing that such sentences were administered upon those caught, it also demonstrates the harsh and desperate conditions under which the rural labourer had been placed.

In more normal circumstances, the keeping of law and order within the village of Westbourne was placed in the hands of the parish constable. It was an office that went back into the dim and distant mists of time. Appointed annually by a meeting of the parish vestry, the holder was usually a young and trusted member of the local community. Experience and intelligence were not necessary requirements while those with money, whose turn it was to serve, would often pay someone else to do the job. Admittedly, the position was not particularly onerous, especially in a relatively law-abiding village. Included within the duties of any appointed parish constable were the inspection of local alehouses (where plenty of free drinks were usually available) and the taking of responsibility for any stray cattle found roaming in the parish. If necessary, of course, the occasional arrest was made, the offender having to be taken to the local village lock-up. Where possible, and given that anyone arrested was likely to be known to (or even a friend of) the parish constable, such individuals were quickly released once they had sobered up.

Sometimes, of course, occurrences out of the ordinary might take place. The events of 1830 were just such an example. However, for the village of Westbourne another out of the ordinary event took place some twenty-four years later. This time it was an incident that the parish constable not only had to deal with, but it was an expected part of his duties. At the Cricketers' Arms, a taphouse situated on Commonside, the landlord had stepped right out of line. Often cautioned for his wild and drunken behaviour, Emery Spriggs had apparently murdered his wife.

On the evening of Friday 6 January 1854, the local branch of the Foresters, a charity and mutual support society, were holding their New Year's dance at the Cricketers' Arms. With a membership principally made up of poorly paid agricultural labourers, the choice of venue had to reflect the limitations of the pocket. While the Cricketers' Arms was cheap, it was also a little seedy. The landlord and landlady were friendly enough, but they did have an unfortunate tendency to drink a good deal of the alcohol before lapsing into one of their seemingly unending arguments.

The dance itself passed off peacefully enough, with the last couple leaving during the very small hours of the following morning. As might be expected,

with the tap being open until so late, both the Spriggs were seen to be in their normal state of intoxication. However, unlike most evenings, the two of them seemed relatively contented and few angry words passed between them.

To make the night just a little more special, the Spriggs had employed William Fletcher as waiter. Unmarried and aged twenty-six, it was not his normal means of employment. In common with many of those at the dance, he was also a farm labourer. However, given that it was mid-winter and few farmers were looking to employ additional labour, Fletcher was happy to take on this extra work.

Whether the fifty-five-year-old Rebecca Spriggs had any feelings for their temporarily employed waiter is difficult to say. Certainly she went out of her way to be nice to him. With the dance having finished and the Spriggs, together with young William Fletcher, having brought some tidiness to the main parlour, Rebecca proceeded to cut him some meat for his breakfast. It was now 4.30 in the morning with the landlady carefully wrapping the meat in some newspaper. To Fletcher's surprise, she suggested that he should go into the tap and ask her husband to pour him a mug of beer. This he proceeded to do, finally leaving the Cricketers' Arms shortly before five o'clock.

At that point all hell seems to have broken loose. While the two had managed to avoid strong words while the dance was underway, they now let rip. Emery accused his wife of being just a little too friendly towards the young unmarried farm labourer. To Rebecca, this was quite unacceptable and she was forthright in her defence. Perhaps more full of drink than was his usual habit, Emery temporarily left his wife and went to a storeroom at the back of the building. A few minutes later he returned with a shotgun. His anger still unabated, he pointed the weapon in the direction of his wife and pulled the trigger. A massive explosion reverberated around the tap and she fell to the floor. It was obvious where she had been hit, blood beginning to ooze from a wound in her forehead.

It was soon clear to Emery Spriggs that her wound was fatal and that he was responsible for her death. Whether he made any efforts to save her is unclear. However, he did attempt to get some assistance, calling upon his immediate neighbour, Martha Piles. She lived in an adjoining cottage. Going into the street, he positioned himself under her bedroom window.

'Mrs Piles,' he called out. There was a long delay before the neighbour eventually opened the window. The sun was still three hours from rising with the street completely unlit.

'Who's there?' she asked as she tried to make out the shadowy shape that was just discernible under her window.

'Mrs Piles, will you come into my house?' Spriggs requested. 'There is a dead woman in my house.'

'Oh Spriggs, don't say that.'

'Yes, I have shot her.'

Before long Martha Piles, having been firmly shocked out of her sleep appeared at the door. Dressed and ready for the occasion, she also carried a lantern. Joining Spriggs at the front of her house, they walked the short distance to the Cricketers' Arms. As she entered through the main door, she noted that there was a candle burning in the entrance passage, but it only cast the smallest glimmer of light. With this, and the lantern she carried, it was just possible to make out the body of Rebecca Spriggs. Lying on the floor of the passageway, she was laid flat on her back with her head resting on the sill of the taproom door.

'Oh Spriggs, what have you done?'

'I have killed her. Please get help.'

'Who shall I get?'

'Mrs Hedges and her daughter,' referring to Ann Hedges and her twenty-year-old daughter who lived about 20 yds from the taphouse. 'I will bide with the body.'

Martha Piles assented, wondering whether she should offer some comfort to the man who was just beginning to show the first signs of grief. It was not a task she relished, especially as she was unclear as to Spriggs' current feelings to his now lost wife. However, with his next declaration, things became a little clearer.

'Becky, I always loved you and I love you now,' he remarked while looking intently at the body. Turning towards Martha Piles, he added to his earlier request, 'Now go and make haste and I will stay with the body'.

Although the distance to Mrs Hedges' house was no more than two stone throws, it was to be some twenty minutes before Martha Piles returned. In that time she not only had to arouse the fifty-eight-year-old widow from her sleep but also explain what had taken place. In addition, Ann Hedges and her daughter had to dress and prepare for the sight they were about to witness.

When Martha Piles returned with the two women, the scene in the taphouse was exactly as she had left it. The body had not been moved while Spriggs himself was in the middle of the taproom leaning against a table. Upon their entry, he spoke to all three of them.

'Take my dear wife and do your duty by her'. None of the woman required a further explanation of what he meant.

'It is not decent to let her lie there,' Ann Hedges stated. 'We had better move her into the parlour.'

'You three can do it.'

'Would you, Mr Spriggs, light us,' Ann further suggested.

'Yes, I will,' as he lit a candle and held it over the body.

Not giving a thought to the summoning of the parish constable, the three women carefully removed the corpse from the passageway floor to the side parlour. Here they set about washing the body, wiping away all signs of blood from the wound that was on the right side of the head. Their work of cleaning up also included the removal of a great deal of Rebecca's blood that had dribbled on to the floor of the passageway where she had been shot.

Spriggs, who for his part was far from sober, had quickly returned to the taproom. When Ann Hedges rejoined him in this same room, Spriggs summoned her to a chair that he had pulled across to the fire.

'Oh Mrs Hedges, come and sit down by me,' he suggested. 'No tongue can tell my trouble.'

Between them, they decided on the course of action that needed to be taken. One might have expected Ann Hedges to suggest informing either James Guyatt or George Cole, the two parish constables. However, this she failed to do, having more confidence in Dr Hicks, the local medical officer who lived close by. Having confirmed that he should be called, Mrs Hedges sent her daughter to bring him as soon as possible.

That Dr Hicks was the first outsider on the scene reflects the low level of regard that villagers in Westbourne had for their two local constables. The holders of this office were simply not considered important enough, even in the case of murder, for them to be immediately contacted. They all, on the other hand, knew the doctor, a professional man and someone with whom they had complete trust to do the right thing.

The vestry had appointed the two current parish constables during the previous year, but neither made particular haste to the taphouse after being eventually summoned by Ann Hedges. Between them they separately shared their official duties, but a murder in the village was obviously something that required their combined attention. George Cole was the older of the two, being forty-eight years of age. He was a wheelwright by trade and employed three men in a shop located close to the main village square. His younger partner in this sharing of constabulary duties was James Guyatt. Aged thirty-one and married with two children, Guyatt was a shoemaker who employed two assistants in a shop that was also located close to the village square.

Of particular significance was that neither man had any training in the performance of policing duties. This, however, was not especially unusual as parish constables were rarely given training. As such, they were heavily

Westbourne viewed from Commonside. In the immediate foreground is Union Yard, modern houses now occupying the site of the former Westbourne Union Workhouse where Emery Spriggs resided for the final months of his life. Further along Commonside is the Cricketers' Arms, a building that has also undergone considerable change since the days of Emery Spriggs.

dependent upon their own sense of what was the correct thing to do in any situation. Denied a uniform, or any badge of office, their authority was really quite limited and was entirely dependent on the goodwill of all others who lived in the parish.

As it happens, the whole system of appointing parish constables was under increasing criticism. No longer was it felt that rural communities should be so dependent upon temporarily appointed amateurs to secure their safety and wellbeing. In contrast, towns and cities were usually much better policed, this following a series of recent reforms. In 1836, for instance, nearby Chichester had acquired a formal Watch Committee and had completely replaced the earlier policy of employing night watchmen.

This severe lack of organised policing in country areas had resulted in the passing of the Rural Constabulary Act in 1839. Under this act counties were empowered to establish a professional police force that would assume powers for policing all areas not already covered by a borough-financed force. The act, however, was not compulsory, with only a limited number of counties having

chosen to form an independent constabulary by 1854. West Sussex was not among them, failing to create its own rural force until 1857.

Upon the creation of that new West Sussex Constabulary, Westbourne was to receive, in 1857, one full-time police officer in the person of William Cragg. A young man in his early twenties, he took a centrally situated lodging room that was run by a certain William Collins. Although he had much wider powers than his two predecessors and wore a uniform that clearly advertised his authority, he would not have found his appointment particularly easy. In more ways than one, he was an outsider. While both Cole and Guyatt had lived their entire lives in the village, Cragg was a foreigner, having been born in Petworth. Furthermore, he represented government intrusion into the daily life of a village that had previously been largely detached from the outside world.

Cole and Guyatt, at the time of the murder, were in an interesting situation. With reforms of policing in West Sussex very much on the horizon, they were among the last of the parish constables to serve in Sussex. Their handling of the murder was to be very different to how any uniformed successor might have behaved. To begin with, and as previously noted, neither Cole nor Guyatt arrived at the scene of the crime particularly early. As it happens, Guyatt appeared at the Cricketers' Arms at around 10 am, with George Cole arriving about an hour later. Both men, of course, had their own separate businesses, with the organising of these obviously needing to take priority over the arrest of a possible murderer.

This lackadaisical approach duly continued. Guyatt, on his arrival, had already sat down in the tap with Spriggs and between them they reviewed the events of the night. However, it was a fairly pointless task as neither Guyatt, nor Cole on his arrival, proceeded to take notes. It was more of a friendly three-way conversation.

As for the body, this was more or less ignored with no description of the scene being officially recorded at that time. It was fortunate that Martha Piles had been called so early, for she was at least able to confirm the time of death. Indeed, she had the possible makings of a forensic scientist (but no actual interest in becoming one) as on first coming across the body, she had placed her hand on the head of the body to check its temperature. Later she was to recall to the county coroner that the body was still warm. At the very least, this confirmed, with near certainty, the actual time of Rebecca Spriggs's death.

And now we come to the real core of rural policing in the age immediately before the formation of the West Sussex Constabulary. In those days, the amateur parish constables served only as a conduit with nothing more really expected of them. The real enforcers of law were county magistrates and coroners. They were the only ones with any real training or experience to

The village of Westbourne, little changed in its central area from the way it appeared in the nineteenth century, when policed by an amateur parish constable.

investigate and apprehend the perpetrators of serious crime. If, for instance, Emery Spriggs had been less compliant and had chosen to make a run for it, then it would have been a magistrate who would have taken action. With authority to raise the 'hue and cry', this taking the form of an all-points-bulletin circulated to nearby parishes and towns, others, be they parish constables or members of a borough police force, would have compared the description of any newly arrived strangers with that of the wanted individual.

However, Spriggs chose not to make a run for it, so leading to the implementation of an entirely different procedure. Now, because of the existence of a body, John Ellis, a county coroner, took up the matter. It was through his examination of the body and his interrogation of the various witnesses that a decision could be taken as to the immediate future of Emery Spriggs. However, any thoughts garnered by Ellis had still to be confirmed by a jury specially sworn in for the occasion.

To meet this last requirement, the coroner summoned his court, which assembled in the schoolroom of the workhouse on the afternoon of Monday 9 January. Here were brought together twelve 'good and lawful men' from the parish of Westbourne. Their first task was that of declaring under oath that they had viewed the body of Rebecca Spriggs and were able to confirm that she was quite dead.

At last, a degree of professionalism had kicked in. The various witnesses, William Fletcher, Martha Piles and Ann Hedges were called and repeated the original statements they had already made to the coroner and which had been signed. To these the jury carefully listened, also aware that Emery Spriggs had freely admitted to the shooting of his wife. Not surprisingly, their subsequent retirement was fairly brief, returning with a verdict in only a matter of minutes. As presented by Richard Kelsey, their elected foreman, it was announced that Spriggs, 'not having the fear of God before his eyes and moved and seduced by the instigation of evil... did... feloniously, wilfully and of his malice aforethought kill and murder the said Rebecca Spriggs.'

However, it was not in the power of the coroner to pass any sentence as his court was simply serving in the capacity of evidence gathering, before passing the matter to a court that had the authority to both re-examine the evidence and hand out a suitable sentence. For this reason, with everything pointing to his guilt, Emery Spriggs was ordered to appear at the next Sussex Assizes, this to be held at Lewes in March.

Again, a jury was involved and again Spriggs admitted to the killing of his wife. However, in listening to the evidence and considering all the facts, the judge and jury were to spare him the morning drop. Instead of being found guilty of murder, Spriggs was found guilty of manslaughter. In listening to all that was said, the jury accepted that he acted in the heat of the moment and had not really intended to kill his wife. Undoubtedly Martha Piles saved him. In making that earlier statement to the coroner, she had quoted the words used by Spriggs when talking to the body of his dead wife, 'Becky, I always loved you and I love you now'. Without those vital words, Spriggs would almost certainly have been facing an appointment with the public executioner.

As for his sentence, Emery Spriggs was to be banished from the land of his birth. Sent to one of the prison hulks moored in Portsmouth Harbour, it had been ordered that he should be transported to New South Wales 'for the term of his natural life'.

Well, at least that was the wording of the sentence as actually laid down. In reality, he was only out of the country for about seven years. No reason is known for his unexpected return, but the evidence is clear enough. It comes from his death certificate, which records that at the time of his death in August 1875, his place of abode was the Westbourne Union Workhouse. Should Spriggs have chosen to do so, during this final period in Westbourne he could easily have glimpsed his former home, that of the Cricketers' Arms. Both the taphouse and the workhouse were, as it happens, positioned on Commonside.

SLOE FAIR OR NO FAIR

During the nineteenth century, Chichester underwent considerable change in the means by which it was policed. At the time when Private John Holloway had been hanged, the city had relied upon two different and rather ill co-ordinated policing bodies. One operated during the day and was funded by the Corporation (or town council); these were the paid constables of the city. The other was a force of seven night watchmen who served during the hours of darkness; they were financed and governed by the Board of Guardians, a separate body whose main task was overseeing the needs of the poor. However, in being responsible for raising the poor rate, it was also realised that this same money might allow a number of additional tasks to be taken on by the Guardians.

Each evening the watchmen of the night reported to a specially built watch house where they were each issued with a rattle, lantern and truncheon. From here they proceeded to their area of patrol, having to walk the length of their beat every thirty minutes, 'crying the hour at about every forty yards during the round'. Providing limited comfort were watch boxes, these used by the watchmen when they were not walking their beat. Should a wrongdoer be apprehended then he or she could be taken to the watch house where the superintendent was usually to be found. Specifically, they were empowered to arrest 'all malefactors, disturbers of the King's peace and all suspicious persons, night walkers and persons misbehaving themselves'.

However, the efficiency of these two bodies combined must be seriously questioned. Neither was subject to a high degree of scrutiny while the individuals themselves were not necessarily those best suited to the tasks they performed. Furthermore, they only operated within the city, being a force for the deterrence of casual crime rather than a force for preventing and detecting the more determined criminal. For this reason, the city of Chichester had a third arm for the enforcement of law, that of a local Society for Prosecuting Felons and Thieves.

Meeting twice a year at the Dolphin Inn, the society was first formed in 1793. Consisting of exactly 100 members, each of whom contributed financial support to the society, it being agreed that if any of them should be robbed or in 'any way injured in his property' he should give notice to the society. Once it was agreed that the offender should be pursued, the society would provide the necessary funds for the issuing of a reward for the apprehension of the offender, together with all costs connected with subsequent prosecution.

Another development to reduce the incidence of nocturnal crime in Chichester was the introduction of lighting. Again, this had fallen upon the Guardians to finance and manage the initiative, with such lights first appearing in the city in 1753. Throughout the city and immediately beyond the walls, over 100 oil lamps were eventually in position. Lighting in the city was further improved in the 1820s when the Guardians oversaw the introduction of gas lighting. Again, there was a clear connection with night-time security, payments for both the night watch and gas lighting being made from the same account.

A much more planned approach to policing in Chichester was brought about in 1836, a result of municipal corporations now being required by Act of Parliament to be far more proactive in their arrangements for law enforcement. In order to comply, the City Corporation now took over all responsibilities for policing and also formed its own Watch Committee to oversee the workings of a newly created force. At the time of its inception, this force consisted of a superintendent, a senior policeman and six constables. The superintendent received a salary of £40 a year while the senior policeman and constables received 15s and 14s per week respectively.

The uniform of the Chichester Corporation Constabulary consisted of a black frock coat with closed high neck collars. In addition, each constable had a leather belt with a buckle that displayed the city coat of arms while on the coat were the individual constable's number and a small metal badge that also had emblazoned upon it the city motif. Initially, top hats were worn, but helmets later replaced these. In common with the belt buckle and coat badge, the helmet also displayed the city coat of arms. While on duty, constables wore a striped red and white band on the left cuff and carried a truncheon that, during the early years of the new force, was highly decorated. In later years, however, truncheons of plain wood were introduced.

In 1857, following the creation of a separate rural constabulary in West Sussex, a second police station was built in Chichester, this to serve only the needs of this new body. Constructed on a piece of land in Southgate (the site of the present-day bus station), it served as a sub-station with the county constabulary's main building situated in Petworth. As to the new building in

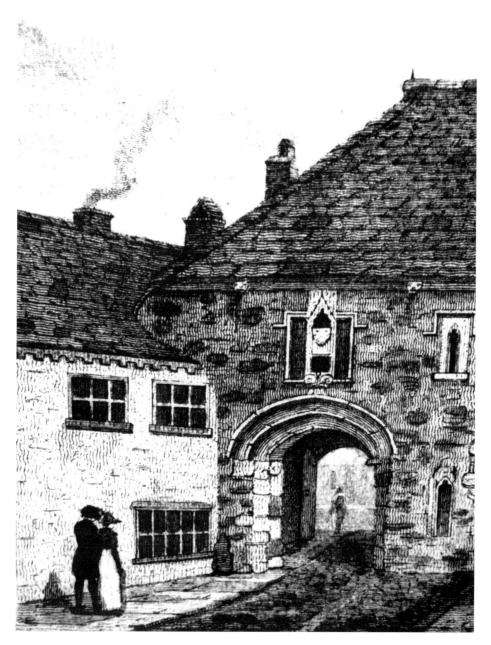

Canon Gate where the original Chichester 'pie powder' courts were held.

Chichester, this was officially opened in March 1860, with local newspaper reporters given the opportunity to inspect the new building. The following appeared in the *West Sussex Gazette*,

> We last week took a peep over the new police station, recently erected at a cost of £2,000 near the railway crossing. The building, which appears to be well adapted for the purpose, includes six cells, a strong room, a guard room, an office for the superintendent, and residence for the same, and a residence for a constable with a single man lodger, and all the necessary outbuildings of coach house, stable, hay loft &tc. [*West Sussex Gazette*, 15 March 1860]

The establishment of the new rural force did much to reduce the higher levels of crime that were being reported outside the city. Indeed, the rural force, subject to much higher levels of discipline and general supervision, was in a much better position to both deter and detect. Indeed, unlike the city force, it even had its own plain-clothes detectives. The *West Sussex Gazette*, was certainly most fulsome in its praise of the new force when, in 1858, it informed its readers,

> Many persons had opposed the new police act on the grounds that a central authority would exercise too much power. However, in the western division of the county one felt perfectly protected against the criminal, because the criminal was certain to be detected by the efficient new police force. One can sit around one's fireplace and feel quite secure in the knowledge that the police were about their business. [*West Sussex Gazette*, 14 January 1858]

Not surprisingly, with two separate police stations in Chichester and a sometimes-unclear distinction as to where the duties of one force began and the other ended, there was a certain degree of pressure for the two forces to combine. However, such an arrangement would probably not have come about if it had not been for outside pressure. Once again, central government intervened, a general piece of legislation being introduced in 1858 that required all boroughs of less than 15,000 to merge with county constabularies. At that time the population of Chichester was less than 9,000.

The separate borough force of Chichester now ceased to exist, with its officers incorporated into the county force and expected to exchange their city uniforms for that worn by the West Sussex constabulary. This uniform consisted of a helmet that displayed the Sussex county badge, a high neck black frock coat (with the county badge and individual number on the collar)

with an additional cape to be worn in winter. Each constable, while on duty, carried a plain wood truncheon, metal handcuffs and a whistle. At night an oil lamp attached to a black trouser belt was added to the various accoutrements carried.

Whether it was the night watchmen financed by the Guardians or the constables of the borough or county constabularies, there was one particular event that each, in turn, had to give much attention. This was the annual Sloe Fair that was held on the north side of the city during the month of October. An occasion that was eagerly awaited by many Cicestrians, others in the city looked upon it less favourably. An excuse for general merriment, there were times when things simply got out of hand or when drunkenness combined with anger resulted in uncontrolled rage and personal injury. As October of each year approached, special arrangements had to be made to ensure that there was a sufficient policing presence to rapidly quell any outbreak of disorder.

The origins of the Sloe Fair can be traced back to the eleventh century and to the reign of Henry I. In 1107, this particular monarch granted to Ralph Luffa, bishop of Chichester, the right to a fair lasting eight days. It was left to the bishop to determine when it should be, Luffa deciding it should open on the Feast of St Faith the Virgin (6 October) and close on the Feast of St Edward the Confessor (12 October). At that time the fair was held in the area of the Canon Gate.

The advantage to the bishop of holding a fair was that of having the right to establish a court that administered justice during the period of the fair. Primarily aimed at offences connected with trading, it often took on a wider jurisdiction with all other courts in the town suspended. The patron retained fines levied. Known as 'pie powder' courts, in reference to the dusty-footed merchants who often attended these courts, their establishment by the bishop during the period of the fair was occasionally challenged by the Corporation. In 1407, the then mayor of Chichester, Thomas Pacchyng, sought a boycott of the bishop's court. This resulted in only two merchants bringing cases before the 'pie powder' court. Even so, Pacchyng was sufficiently incensed by these two merchants ignoring his instructions, that one of them was subsequently imprisoned.

That Bishop Luffa's fair eventually became known as Sloe Fair was because of the fair's later removal to a field near North Gate where a sloe tree was growing. In fact, so much of a tradition did the fair become, that the field in which it was annually held, became known as Sloe Fair Field. Standing in the south-west corner of modern-day Oaklands Park, bordered on its south and west sides by Broyle Road and Oaklands Way, it is still the site of the fair, but now serving as a car park throughout the rest of the year.

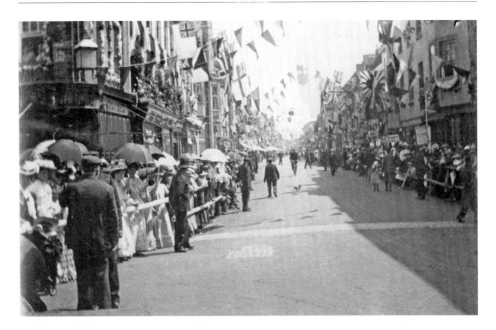

Whenever large crowds assembled there was always a need for additional policing. In Chichester, partly through efficient policing, such events, including the Sloe Fair, normally passed off peacefully. A vast crowd assembled in July 1904 for a visit to the city by Edward VII. Members of the West Sussex Constabulary are to be seen lining the route as it winds along East Street.

Where any vast crowd assembles, then there is always the chance that some might take advantage of the situation for their own nefarious ends. Apart from theft and drunkenness, there were also occasional bouts of violence. One of the earliest recorded of the more serious crimes associated with the Sloe Fair was a murder that took place during the sixteenth century. This was on the evening of 12 October 1597 when a quarrel took place within the grounds of the fair, and which resulted in the death of John Kennet, a tanner from Petworth. The man responsible, Thomas Tapper, a soldier from Portsmouth, had taken a rapier to him, striking him about the neck and chest. Tapper, after appearing before the assize court, was sentenced to be branded on the left hand. An identical sentence was also handed out during the following year to Ralph Addessen. This, however, was not in connection with the Sloe Fair, but as a result of an outbreak of trouble at the St Lawrence Fair (9-11 August). Addessen, a yeoman of Chichester, became involved in an argument, killing another Chichester man, Henry Woodnet with a rapier.

The 'pie powder' court was still operating in 1729 when any wrongdoers would be brought into the upper room of the Canon Gate for summary trial.

In a manuscript book held in the cathedral chapter, a description for the setting up of the court is given,

> Let the cryer (John Barnes) make proclamation on the south side of the High Cross as follows: 'All manner of persons that have to do in, or intend to have to do at the ancient Pavillion Court of the Right Reverend Lord Bishop of Chichester, holden this day for the city and the liberties thereof, with the Fair called Sloe Fair, for the time and space of eight days, beginning this day, come forth and give your attendance. God save the King.'

Having so made this proclamation at the Market Cross, John Barnes, the town cryer, was then required to make a similar announcement at the various city gates. Having completed this task, he was then allowed one half crown for his breakfast.

It was the introduction of the Gregorian calendar in 1752 that led to the date of the Sloe Fair being changed. Up until that time it had remained more or less faithful to its original start date. However, with the introduction of the new calendar, the Sloe Fair and the earlier Michaelmas Fair were now in much closer proximity. In order to bring about a clearer separation, the Sloe Fair was moved to 20 October. Possibly it was also from this time that the number of days given over to the fair was reduced from eight to one.

The Sloe Fair continued to see many petty outbreaks of lawlessness during these years, drunkenness was especially common but so too was theft, the passing of counterfeit coins and any other little ruse that might achieve an easy income. Frequently, newspapers reported outbreaks of violence, these often involving soldiers from the barracks constructed on the Broyle. Even members of the borough constabulary were not immune from the influence of the Sloe Fair. On several occasions constables of this force, instead of ensuring the fair passed off peacefully, chose to join the general merriment of the day. One well-recorded case took place in 1881. On that occasion, Police Constable Phillips (PC4), had to apologise to the Watch Committee for being drunk while on duty at the fair. In a letter explaining his behaviour, he duly promised that such an act would not be repeated. The normal punishment was a fine of 7/6d and the threat of dismissal if found drunk on duty on any future occasion. It seems that Phillips might well have been as good as his word, being one of those who, in 1889, were transferred into the county constabulary upon the two forces being amalgamated.

The image of the fair being a catalyst for bad behaviour was one that was readily accepted by the middle class of the city. Furthermore, as ratepayers who

funded the police force, they had an exaggerated idea of just how much policing the fair was costing them. To bring an end to this supposed season of lawlessness, a campaign was initiated to abolish the fair. In 1904 a number of prominent citizens petitioned the Home Office, indicating it to be the cause of numerous evils. If this could be proved, then closure of the event could be carried out in accordance with the Fairs Act of 1871. Specifically, it was claimed:

1. The Fair is the cause of a considerable increase of immorality and intemperance in the city.
2. The ill-effects upon young children, who are brought face-to-face with scenes of intemperance, immorality, dissipation and excess, which they would never see elsewhere, and hear language of the most revolting description.
3. The cases of crime and breaches of the peace brought before our magistrates at this period are much more numerous than other times, and are clearly traceable to this Fair.
4. The Fair is a nuisance and a cause of annoyance not only to those living near but also to the city generally.

However, this righteous group of individuals had only limited evidence to support their assertions. The Home Office, in collecting evidence, wrote to Superintendent Ellis, deputy chief constable of Chichester, seeking his opinion. While he admitted he neither liked nor disliked the fair, he could not support the claims of the petitioners. The one-day event was not, he indicated, a particular drain on police resources. If ever there was trouble, and here Ellis turned to his own deep-seated prejudices, it was through the presence of 'gypsies'. Referring, in general terms, to this much-maligned group, 'as a dirty and ill-behaved class'.

In fact, the debate over the continuance of the fair quickly transformed itself into a clash between two distinct classes. In his submission to the Home Office, Ellis referred to those wishing to abolish the fair as 'the ruling persons, the better class'. Those opposed to abolition, and whom he clearly did not support, he described as 'the working class'. In putting his own views forward, Ellis felt it would be better if money that they spent at the fair was used instead on 'food and clothing' for their families.

Not surprisingly, working class Cicestrians did not agree. One of their number, Joe Mills, a sixty-two-year-old working cutler, took the trouble to write to the Home Office. Stating his credentials to be that of 'a Chichester man born and bred' he felt that 'doing away' with the fair would be 'a cruel shame'. He felt that those in favour of abolition were no more than a 'small

Policing within the borough of Chichester was never particularly conspicuous, but there was always a good chance, if one was needed, of finding a policeman in the neighbourhood of the market cross. This early twentieth-century photograph shows a member of the West Sussex Constabulary keeping his ever-alert eye on the passing citizenry.

clique' who simply 'didn't like people enjoying themselves'. As well as this letter, Joe Mills was one of a hundred working class signatories to a petition that was also submitted to the Home Office.

Throughout 1904 the battle raged. Increasingly it became clear that the 'ruling class' had an ulterior motive. Their reason for wishing the fair to be abolished was so that the land upon which it was held, Oakland's Park, could be used for the building of an enlarged workhouse. With the continuing expansion of Chichester's population, great pressure had been placed on the Guardians, with the workhouse too small for current needs. Furthermore, a fire that had destroyed Westhampnett workhouse, this having accommodated some of the city's poor, had not helped matters. Oakland's Park, which stood next to the existing building, was seen as the only available land upon which an extension could be constructed. However, in order to abolish the fair, under the terms of the Fairs Act, it had to be proved that the fair was a general public nuisance.

The 1904 Sloe Fair, held on Thursday 20 October, was viewed with great interest. Many expected it to be the last ever, especially if there was a general

outbreak of disorderly behaviour. In the event, the fair saved itself. On that glorious occasion, there was very little that anyone could complain about. Admittedly, in the evening, a few people engaged in throwing confetti and squirting water, but even this did not prompt the involvement of the police. Anyway, such minor disturbances were overshadowed by the attendance of massive well-behaved crowds throughout the day. Each and every fair-goer was drawn by the good wholesome fun provided by equestrian displays, shooting galleries, coconut shies, ginger bread stalls, a china emporium and fried fish stalls. A major attraction was a mobile cinema, a temporary rival to the more frequent showing of films at the Corn Exchange. In the *West Sussex Observer,* it was noted,

> The cinematograph did a roaring trade. On the platform outside the booth a young girl, clad in cheap finery that makes so brave a show under the glare of naphtha lights, was dancing to the tune of a popular song, blared from the pipes of a mechanical organ.

Apart from the mobile cinema, the other major attraction was the steam driven switch-back railway that was electrically illuminated after dark. Again, the local reporters were impressed; pointing out that the lighting system was well in advance of that used in Chichester. Here, the city lights were still dependent on gas, this not changing to electricity until 1909.

The only real critics of the fair on this occasion were members of the Salvation Army. Throughout the day, their speakers proclaimed the Fair a moral danger, but their efforts were largely ignored. Furthermore, with the day passing off so successfully, there was little that the 'ruling class' could do to bring about its demise.

Seemingly, the Sloe Fair had already transformed itself by that date. Certainly, in the 1880s it had been an event best avoided by the more genteel of the city. However, since the amalgamation of the borough and rural forces in 1889, policing of the fair was much more efficient. Most certainly there were no more cases of drunken police officers joining the revellers. If those who, in 1904, wished to see the abolition of the event had bothered to visit the Fair, they would have seen how things had improved. Furthermore, the Sloe Fair continued to improve, with police records showing that the day of the fair was no more prone to crime than any other day of the year. Search the existing daily police incident books for the 1920s and 1930s and it is almost as if the fair did not really exist. Quite simply, there are no entries because it was virtually crime free. Most certainly there was a very different attitude to the fair by then, so allowing one middle class supporter of the fair to write,

In 1939 plans were made to convert Oakland Park into a sports ground. In doing so, Sloe Field would eventually have been merged into the overall design with the fair unlikely to survive such an onslaught. This map produced by the borough council at the time, shows the full splendour of the overall plan.

The Sloe Fair, as it exists today is a pure piece of jollification. Some years ago it developed a good deal of rowdyism, but in recent years this element has been entirely lacking and the whole thing is entirely well organised. There is no more talk, as once there was, of doing away with the ancient festival, and the people of Chichester, who year after year prove by their attendance their fidelity to tradition, would rise to a man – and especially to a child – to execrate the soulless caitiff who in the 20th century should suggest depriving them of their pet day. [W. Victor Cook, 'Chichester's Sloe Fair'.]

Indeed, as the writer further noted, the day was even allowed as a school holiday, showing the clear support that even the establishment of the city was now giving to the one-day event. Again, as the previous writer observed,

Every year on the 20th October, all true dwellers in the ancient city of Chichester, man, woman and child, throw off the cares of the world, the deceitfulness of cares and riches or poverty as the case may be, and flock to the Sloe Fair, there to indulge in an orgy of hurdy gurdies, ferocious lions, fat women, 'rides of death', and all the familiar manifestations of noisy, childish excitements comprised in the expression, 'all the fun of the fair'. Strangers within the gates may marvel, as they often do, that a whole population should so heartily give itself up in these sophisticated days to enjoying a function which, in many places, would make it appeal only to the more simple minded, not to say rowdy elements of the inhabitants. [W. Victor Cook, 'Chichester's Sloe Fair']

One final attempt to bring about a radical change to the Sloe Fair came about on the eve of the Second World War. At that time Walter Stride, a many-times mayor of the city, had persuaded the city council to purchase both Oaklands Park and the adjoining Sloe Fair Field. The object was to convert the entire 43 acres into a recreation and sports amenity. If this had come about, it had been decided that the site of the fair would be relocated, possibly to the nearby grasslands immediately below the city walls. However, nothing came of the project, with the original field continuing to act as host to the fair. Indeed, by that time, the city corporation had done much to turn the field into a reasonable source of income, encouraging both circuses and other eventers to use the site. Its conversion to a car park dates to 1960, it being specifically required that the former area of the field continue to host the fair and other events when required.

Thus, the Sloe Fair continues to survive, an annual event that still comes to Chichester but now, unfortunately, is a mere shadow of its former self. Each

year, on 20 October, a travelling fair sets up on the traditional site that was once Sloe Fair Field, and attracts a goodly number of the city youth. Crime and disorder are low on their agenda with little requirement of a police presence. Perhaps the greatest inconvenience offered by the fair is the temporary loss of a city car park. Perversely, of course, if it were not for the existence of the fair on that traditional site, there would be no land available for a car park in the first place.

'OH MURDERER, SHE WAS THE JOY OF MY LIFE!'

George Hoad's lifeless body was discovered on the garden lawn of his house in Westhampnett Road shortly after midnight. The cause of death was not difficult to ascertain. Suicide. Some thirty minutes earlier Hoad had swallowed a deadly dose of potassium cyanide, a cup containing this substance found under the garden privet hedge. Providing confirmation of it being suicide was a note, left by Hoad and addressed to his wife Eva and daughter Ida, 'I am writing this to wish you both good-bye, and forgive me for what I am about to do'.

A fastidious man in life, Hoad was determined that his immediate family should be inconvenienced as little as possible. To the opening lines of his suicide note were added instructions as to the disposition of his property and clear directions as to where the deeds of the house might be found.

At the subsequent inquest, held at the Royal West Sussex Hospital, it was noted that Hoad, a carpenter, had recently become unemployed. It was upon this that the coroner chose to dwell when recording a verdict of suicide while of unsound mind.

'I am satisfied that when he was out of work he did get very depressed and worried,' the coroner affirmed. 'I feel quite sure he was not realising the full effect of what he was doing at the time. He desired to get away from his worry.'

The coroner, with these words, had done George Hoad a terrible disservice. Unemployment may not have helped, but it was by no means the true cause. For many years previously, Hoad had been under a cloud of deep and unrelenting depression. His thoughts constantly strayed to one horrific event that had occurred more or less nine years earlier in February 1924 – the brutal murder in Chichester of his eleven-year-old daughter.

It was an event that any father would find impossible to dismiss from their mind, but made worse for Hoad by his own mistaken feelings of guilt. Could he

46

George Hoad. His life became meaningless upon the murder of his young daughter.

have done something that would have saved his lovely Vera from the clutches of that hideous fiend who took her life? Should he have arranged for Vera to have been collected from the house of her music teacher on that dreadful evening, rather than let her return home through a number of ill-lit streets? Although he had no real reason to blame himself, these thoughts constantly ran through his mind. For George Hoad, the value of that lost job was not one of money but as a means of forgetting. Only when concentrating upon his work could he occasionally overcome the pressures of his imagined guilt.

It was a tragic and terrible event that neither George, nor his wife Eva and two daughters, Eva and Ida, could ever hope to reasonably forget. In a desperate attempt to reduce the number of simple everyday reminders of that appalling event, the family had, at least, taken one immediate action. They had moved from their earlier home in St Pancras, from where Vera had set out, never to return, to Westhampnett Road. An act that could never expunge those memories of what had happened to their sweet daughter, it only served to prolong the suffering. And in the garden of that new house, George Hoad had taken his own life.

Two dates in the year were crucial to Hoad's suicide: 15 July and 25 February. The first was the date in which his little girl's birthday had fallen and

North Lodge, now on the verge of demolition, was once the home of John Newman, steward to Graylingwell Hospital. It was while returning from Newman's House that Elliott passed Regnum Field and came across the body of Vera Hoad.

the second was the day upon which she had been taken from him. In the build up to that final successful suicide bid, these dates had featured prominently. In August 1932, just a few weeks after the date that would have marked Vera's twentieth birthday, George had bought the potassium cyanide crystals from a local chemist. To conceal their actual purpose, he had written into the statutory poisons book, kept by all chemists at this time, that they were required for the destruction of a wasps' nest.

How close he came to taking the poison that summer is not known. However, it is a fact that sometime during that summer he had been taken seriously ill – losing the use of both legs. Whatever his feelings on the days that had followed that uncelebrated birthday, his depression was much greater in the early February of that following year. He knew, on this occasion, that he could not face the build-up to the terrible anniversary of her disappearance and murder. Now out of work, he had nothing to distract his memories and that bitter feeling of guilt. On the early morning of Friday 3 February 1933, the despondent and truly desolate George Hoad took his own life.

The young and innocent Vera Hoad had been an ideal daughter. A happy child, she was attentive to her schoolwork and unhesitatingly carried out her

Regnum Field. Now an open area of unfenced ground, it lies adjacent to Blomfield Drive (formerly Love Lane) and offers nothing in the way of clues as to the tragedy once played out on this piece of land over eighty years ago.

share of the household chores. Furthermore, she had a certain musical talent that had resulted in her having received lessons every Monday evening. For these, she went to the home of Winifred Rickard at Tyndale in St Paul's Road, normally arriving sometime around half-past five in the evening.

'She had been taking these music lessons for about fourteen or fifteen months, always after school hours and she had been attending during the winter months after dark,' George Hoad subsequently declared at the inquest into his daughter's death. 'We had no reason,' he plaintively added, 'to think otherwise than that the streets of Chichester were perfectly safe.'

On the night of Monday 25 February Vera Hoad had arrived at her music lesson some ten minutes late, through the need to find a piece of music that had been lost somewhere around the house. It was something else that her father had recalled at the inquest, 'When I saw her I had just come home for tea and she was just starting out for her music lesson.'

It had been Eva, Vera's older sister and named after their mother, who had prepared the family meal that night, stepping in for their mother who had been in London for the last seven days for a medical problem. The family had just learnt that Eva, the mother, had been diagnosed with a form of

creeping paralysis that would eventually see her restricted to a bath chair. Also absent from the home was Ida, the eldest of the three sisters; she was currently training to become a teacher and was not due to return home until nearer Easter.

On leaving her parent's home that evening the eleven-year-old Vera was well protected against the cold night air. Already, as she prepared to leave the house, temperatures were falling while there was also a steady fall of sleet. Apart from a dark brown overcoat, Vera was also wearing a green woollen sport's jacket, green coloured tam o'shanter, thick knee-length socks and woollen gloves. With fair bobbed hair and a ready smile on her face, she arrived at Miss Rickard's about fifteen minutes later. Here, she received one small surprise, her music teacher was unwell and she was to be taught by Emma Rickard, Winifred's mother.

An hour later, with the lesson successfully completed, Vera struggled into her overcoat and left through the front door. 'I saw Vera pass out of the gate and turn onward to Northgate,' declared Mrs Rickard when interviewed by the police. 'Because of the hedge in the garden, I couldn't see her reach the end of the road.'

Vera was also seen on this occasion by Charles Fogden of Washington Street who was on his way to Poole's Picture Palace in East Street. At the time he was walking along St Paul's Road and remembers a child with a music case and wearing a tam o'shanter, coming away from Mrs Rickard's gate. Possibly, also, Henry Slaney, who had a tinsmith shop near Northgate corner, sighted her. He recalled a female coming towards him as he re-entered his shop at about 6.45 that same evening. However, to a reporter of the *Chichester Observer*, he added, 'I was anxious to get out of the cold and took no real notice of her other than that she was not very tall and that she carried a small case.'

Neither Fogden nor Slaney recall seeing anyone else in the general vicinity of the girl. It was Eva, at around 7.45 pm, who first registered concern over Vera having failed to return. In setting out to post a letter, she hoped to meet her young sister on her route home. In fact, she walked on past the letterbox, still hoping to catch a glimpse of Vera. On returning home, not having seen any sign of Vera, she expressed concern to her father.

At about 8.30 pm, with Vera now long overdue, the two of them set out to find her, choosing Miss Rickard's home as their first port of call. Knowing, however, that Vera might have taken either one of two possible routes, they separated, with George making his way along New Park Road and Franklin Place while Eva walked along East and North streets. They met up at Miss Rickard's only to find that the girl had long since left.

Still not suspecting matters to be as serious as they assuredly were, father and daughter returned home thinking they must have missed her on the way. Not finding Vera at home, the two once again set out, visiting the houses of a number of her friends. Finally, with panic beginning to set in, they returned home one more time before setting out for the county police station in Southgate. Here they reported Vera to be missing.

The matter was immediately put into the hands of Superintendent Walter Henry Brett. He instructed the night officers to make immediate enquiries and keep a careful lookout for her as they patrolled the streets. At 6 am the next morning, with nothing discovered, Brett once again took the matter up. He issued further instructions for the press to be informed with a description of her appearance circulated to both local and London papers. In Chichester, a description of the girl was also put on to the screens of local cinemas.

Many civilians, including groups of scouts, came forward with offers of assistance and search parties were organised, with these reinforced by police officers from other parts of the county. Initially they concentrated on areas of dense woodland outside of Chichester, together with open spaces within the city.

On the Wednesday afternoon, one of these search parties had covered the grounds of Bishop Otter College, with plans for the next day to move on to the adjoining grounds of the Graylingwell Hospital, a 25 acre site of mixed farmland and surrounding hedgerows. Early on Thursday morning, before this particular search had begun, news came that a body of a young girl had been found within the grounds of the hospital.

The discovery was made by one of the inmates. Graylingwell Hospital, which catered for the needs of patients with severe mental problems, had first opened in 1895. That it included a large area of farmland was a means of ensuring that patients remained active during their sometimes very lengthy periods of confinement. A newspaper report published around the time the hospital first opened, explained how new patients were slowly immersed into such work,

He probably is not called upon to do anything for the first day or two, but he very soon spends his morning in the shops, in the garden or in the farm, either at shoemaking, tailoring, plumbing, or in trimming the grounds or garden, or assisting in field work. Again, there is no compulsion. If he objects he is allowed to remain indoors, but he very soon gets sick of doing nothing and is willing to join others.

Among the patients at the hospital in February 1924 was Elliott, a deaf-mute. Presumably his incarceration within the hospital was not because of any

Graylingwell Hospital, as it appeared at the time of Vera Hoad's murder.

mental illness but due to society not being able to offer him a meaningful life in the wider community. Elliott worked in the dairy and it was one of his chores to deliver milk around the site. At about 8.30, while engaged in this task, he came across the body of the missing girl.

Provided with a small handcart that supported a 20 gallon milk churn, each morning Elliott would pay visits not only to the main hospital buildings but also a number of the surrounding houses that were occupied by senior members of staff. On visiting each building or house it was then his task to fill jugs especially set aside for this purpose. One of his final calls took him along Love Lane, a public way that led through the hospital grounds until it reached an ungated opening that led out onto Summersdale Road. Just by the gate was North Lodge, the house occupied by John Newman, the hospital steward. This was Elliott's final stopping point. Having ladled out the required milk into the jug given to him by Mrs Newman, he began pushing his cart back along Love Lane.

During the previous evening there had been a light fall of snow that had given the grounds of the hospital a strange patchy appearance. As Elliott trundled his cart along the roadway he came to the gate that led into Regnum Field. This was a large ploughed field surrounded by a tall 7 ft hedge. In

*The picture of the eleven-year-old
Vera Hoad that was released by the
West Sussex Constabulary at the time
the girl first disappeared.*

looking over the gate his eyes were caught by what appeared to be a bundle
of clothes partially covered by the newly fallen snow. Only 10 yds from the
gate, it was something that had easily caught his attention. Upon deciding to
investigate, he immediately realised that it was the body of a young girl.

Elliott appears not to have touched or moved the body, but immediately
returned to the main farm building. According to Frank Harris, another inmate
who worked on the farm, Elliott was in an agitated state and kept pointing
in the direction he had just come from. He also kept laying his head on one
side and folded his arms as if indicating someone was asleep. Harris took little
notice of the deaf-mute believing that he was trying to indicate that someone
within the institution had died during the night and that Elliott had seen the
body being removed to the mortuary.

About fifteen minutes later Elliott went into the dairy where he caught the
attention of Mrs Peacock, the wife of the bailiff. Satisfied that Elliott had
something important on his mind, and aware of the search for the missing girl,
she told Harris to go with Elliott and investigate. On their way up the drive,
George Souter the head gardener met the pair and also accompanied them. On
reaching the gate into Regnum Field, they came across the body of the missing
schoolgirl.

Tyndale, in St Paul's Road, where, on the night of Monday 25 February 1924, Vera Hoad had been given a music lesson taken by Emma Rickard.

The police were immediately contacted, with Detective Superintendent Brett among the first to arrive. He apparently took careful measurements, noting the body to have been 10 yds from the gate and about 38 yds from the public road. He also noted various marks on the ground that indicated some sort of scuffle had taken place. As for the body itself, this was partly covered in snow, indicating that it had been there since at least 9.30 the previous evening. The clothes she had been wearing were in a dishevelled state with some items spread around. Within a distance of 15 ft were one of her woollen gloves, her tam o'shanter and music case. On her throat were two distinct bruises, these later examined by the divisional police surgeon, Dr Anthony Barford, who confirmed that asphyxiation, caused by pressure upon the thyroid cartilage, had resulted in her death. He further added that great violence had been used. He also confirmed that the girl had been unquestionably violated.

As regards the time of her death, Barford felt the evidence was inconclusive. The nature of the weather, with part of the week having seen temperatures below freezing point, had helped preserve the body from the normal deterioration process. As a result, other evidence had to be used to determine the time of death. Causing a degree of uncertainty was the simple failure of anyone to

WEST SUSSEX CONSTABULARY.

MURDER

£200 REWARD

The murdered body of **VERA HILDA EMMA HOAD** was found at Graylingwell, Chichester at 8.45 a.m. on Thursday, 28th February, 1924.

Age -- 11 years 8 months. **Hair** – Fair, bobbed.

Dress—Nigger Brown Coat, Green Woollen Tam-o'-shanter, Blue Woollen Scarf, Black Stockings, Black Laced Shoes, wearing Woollen Gloves, and was carrying a black oblong Music Case.

She left her music class in St. Paul's Road, Chichester at 6.40 p.m. on Monday, 25th February, 1924.

The above reward will be paid by A. S. WILLIAMS, ESQ., Chief Constable of West Sussex, Chichester, to any person who will give such information as will lead to the arrest and conviction of the Culprit.

Any information should be communicated to :---

Chief Constable's Office, Chichester, (Telephone 41)

or any POLICE STATION.

3rd March, 1924. **A. S. WILLIAMS**, Chief Constable.

Printed by T. G. Willis & Co 21, East Street, Chichester

Shortly after Vera Hoad's body was discovered on Regnum Field, the police offered a reward of £200 for anyone giving information that would lead to the arrest of the murderer. No arrest was ever made.

George Hoad,

 147 St. Pancras, Chichester (Storekeeper)

Statement of George Hoad as above who saith :-

 I am employed by Messrs Sayers & Sons, Builders Merchants of Chichester. My daughter Vera Hilda Emma was born at this address on 15th July, 1912. She has always been a good, obedient girl, a proper home bird. As far as I know she had only girl friends of about her own age. Her most intimate friend is Queenie Hill who lives near the Post Office at Westhampnett. Vera used to attend St. Pancras Girls School which is right opposite my house, on the other side of the road. She (Vera) has never been missing from home, she has on several occasions stayed week-ends with Queenie Hill, but this has been with our knowledge. I never knew her to have a boy friend, but upon returning from the Congregational Church, Band of Hope, South St. She has spoken of boys chasing her and her friends home. I always understood that this was only boy's play. She used to go to music lessons at Miss Rickards' Tyndale, St. Pauls Road, Chichester every Monday, and lately Thursdays also, from 5.30 p.m. to 6.30 p.m. It would take her 10 minutes to Walk there, and would be home again about 7 p.m. or shortly before 7 p.m. I do not think that Miss Rickards always let n her come out exactly at 6.30 p.m. Sometimes it would be later. I was here last Monday (25th February) and saw Vera leave the house to go to her music lesson She was a bit late in leaving as she could not find a particular piece of music. She left the house at 5.40 p.m. I wnet out some time later and on my return at about 8.15 p.m. my daughter Eva told me Vera had not returned. I did not worry about it at the time as I thought she may have called upon a neighbour, as she had not come home by 8.30 p.m. I went with my daughter...

Miss Rickards and made ...

A sample page from the copious police interview notes taken during the investigation into Vera Hoad's murder. (National Archives, MEPO 3/1603)

St Pancras' church where Vera Hoad's funeral was held.

report seeing her body prior to that Thursday morning. Near to where she was found was a small shed used for the storing of bicycles. Apparently this had been used on a number of occasions since the disappearance with none of the cyclists reporting anything unusual. Similarly, hospital staff frequently used Love Lane including, of course, Elliott. At a similar time on both the Tuesday and Wednesday he had passed the gate and had failed to notice anything unusual. Indeed, on the Wednesday morning, while trundling his cart along Love Lane, he had been stopped by the hospital engineer at a point close to the gate and only 3yds from where the body lay.

Putting these facts together, even the rarely critical journalists of the local *Observer* newspaper found it all a little incredible. In a report on the finding of the body, a short statement was included that declared it to be 'rather surprising that the body was not noticed before if it had been lying there since Monday night'.

However, that the body had definitely been lying there for a number of days has to be accepted. And for this, there are two pieces of important evidence: the weather and the belated admission of a certain Charles Percival Blackman. As regards the weather, it will be recalled that on the day of her disappearance it had been extremely cold. However, there was still sufficient warmth in the air

for a fall of sleet with the ground failing to freeze over. On the following two days, temperatures had continued to plummet, causing the ground to harden over with frost. That Detective Superintendent Brett was able to note signs of a scuffle having taken place in the field, could only point to this having taken place on the Monday evening. Providing almost certain confirmation of this was the evidence of Charles Blackman. Describing himself as a carman, he had been delivering coal to the hospital on the Wednesday when he claims to have seen the body. At the time he had mistaken it for a coat that he thought had probably been left by one of the patients who had been recently ploughing the field.

Having correctly deduced that Vera Hoad had been murdered on the field and within hours of her abduction, only two possibilities now existed: either she had been forcibly brought to the field or had been enticed. Of the two, the former seemed unlikely. To reach the field, even if her abductor had possessed a vehicle, required her to have been walked or carried past North Lodge. Given that the girl appears to have been fully conscious up until the time of her asphyxiation, a simple scream would have been sufficient to alert John Newman or some other member of his family as to something unpleasant happening outside. This then leaves the much more likely possibility of Vera having been enticed by someone she knew.

Armed with these clues, it might well be assumed that an arrest would quickly have followed. A sudden descent upon all male adults that were acquainted with the young girl would almost certainly have resulted in further vital and incriminating evidence being uncovered. But this is exactly what Brett failed to do.

Instead, he was driven by his own personal prejudices that ultimately ensured that Vera Hoad's killer would never be caught. Brett had a strange reluctance to consider the possibility of the murderer being someone local. Instead, he had created within his mind some sort of stereotypical killer, one who could not possibly have had a permanent connection with the cathedral city. In other words, and against all the evidence that confronted him, he was looking for an outsider. To his mind, it would appear no local person could have desecrated the name of this fine city through the carrying out of such a violent and hideous act.

The time of day that Vera Hoad disappeared is of particular significance. It was around 6.45 in the evening, a time of day in which people might have been returning from work or setting out again after an evening meal. Should the killer have been employed, he would either have been approaching his home (or just leaving) at the time he set upon Vera Hoad. This implies a residence

Desperate to solve the murder, the West Sussex Constabulary even sought information from Winnipeg where police had arrested Earle Leonard Nelson (known as 'the dark strangler'). A serial killer and rapist, it was thought possible that Nelson had somehow strayed into Chichester. Given that he had no connections whatever with England, this was a long shot of the most extreme variety. (National Archives, MEPO 3/1603)

that was within a few hundred yards of Northgate, the area where Vera Hoad appears to have been last seen. Furthermore, the decision to place the body on Regnum Field, on the outskirts of the city, could have been determined by a need to mislead the police through ensuring that the body was found nowhere near his own residence. To this end, therefore, the killer may well have lived on the south-east side of the city rather than the north-east side where the hospital was located. Further evidence of the abductor being local, and probably known to Vera, was that of the girl being killed. If allowed to survive, she would almost certainly re-encounter her assailant, leading to later possible arrest.

Ignoring the many clues that suggested otherwise, Brett worked only on the possibility of the murderer being either a stranger or new arrival, rather than someone more established in the area. To his mind, given the profile that he had created of the killer's background and the geographical location of the

body, it seemed clear to him as to where he should start looking. Following only the false clues successfully laid by the killer, Brett's first thought was that he was an inmate of the hospital. However, he soon learned that all patients were inside the building and accounted for by 5.30 each evening, including the evening of Vera's disappearance.

His suspicions next fell upon the murderer being a soldier, the body, while in the grounds of the hospital, not being so far away from Chichester barracks. For those unfamiliar with the area to the north-east of the city, and which includes the Graylingwell Hospital site, it needs to be mentioned that the barracks does, very definitely, lie close by. In fact, the back wall of the barracks lies along Summersdale Road with its main entrance on Broyle Road. Brett's assumption that a soldier might have abducted the girl was further reinforced by Love Lane's frequent use by squaddies accompanied by female companions. At Vera Hoad's inquest, when Brett indicated this particular observation, he was quickly reminded by a member of the hospital staff, that it was also not uncommon to see civilians with their girls walking along Love Lane.

Brett's only evidence for the killer being a soldier, other than proximity to the barracks, was that of boot marks found on Regnum Field. A cast was taken of one of these and, for some unaccountable reason, it was assumed to be an army-issue boot. Only later, after the murder enquiry had been taken so disastrously in the wrong direction, was it pointed out to him that the boot was not service-issue. Unlike an army boot, it lacked the protruding hobnails that were so much a feature of such a boot. Somewhat deflated, but refusing to alter his original decision, Brett now viewed the cast mark as representing the boot marks of a soldier out of uniform.

In pursuing the absurdity of the abductor being a soldier, a great deal of time was wasted. For three whole days, two key members of the inquiry team were tied up at the barracks interviewing each and every recruit. From this they merely discovered that few soldiers had been out of the barracks on the Monday evening, while those who had been were supported by incontestable alibis. Time was even wasted on interviewing recruits who had not arrived at the barracks until several days after Vera Hoad had disappeared.

In taking the inquiry in this direction, Brett also arranged interviews with those who had been employed in a recent repainting of the barracks. Particular interest was shown in a certain Harold Sharp Smith who had left the area at the end of February, returning to his mother's home in Halifax. Again, Smith was not a likely suspect, neither knowing the area particularly well nor having a car. That he was briefly under suspicion seems to have been based entirely on his having left the area shortly after the body was discovered. However, given

that the task he had been employed on had come to an end, there was little point for him to have remained in Chichester irrespective of any connection with the murdered girl.

Interviewed at police headquarters in Halifax, he made it clear that he had been in his lodging house during the crucial period of Vera Hoad's disappearance. With this subsequently confirmed by Aida Game, his Broyle Road landlady, he did at least add that he had gone into town at about 7 pm. Buying a book at the railway station, he walked back to Broyle Road, passing close to Graylingwell Hospital shortly before 9 pm. At that time the roads were fairly empty, although he did pass a young couple walking into town.

Rather than interviewing those with a limited attachment to the city, a more sensible approach would have been that of immediately calling on each and every householder within a reasonable distance of the city centre. This would have encompassed all those who might have been in the area of Northgate on the evening of the disappearance or in the area of Graylingwell Hospital at any time on the days between her disappearance and the finding of the body. Furthermore, given the likelihood of the killer being a local man with knowledge of the area, they may have picked up further clues. Instead, as far as local people were concerned, Brett merely relied upon individuals coming forward.

It was not until a week or more had elapsed that Brett directed his resources to the local population. On 7 March, for instance, pupils at the Lancastrian Boys' School were interviewed. Here, the rationale was that Vera Hoad had been a member of the South Street Congregational church's 'Band of Hope' and of which some of the pupils at the school were also members. The event was duly recorded in the school logbook under the date 7 March 1924,

> Two members of the West Sussex police were allowed to interview all boys in this school – in the presence of the Head Master – who attended the Congregational Band of Hope meetings. The interviews had to do with the Vera Hoad murder case.

At the same time, the area of search was finally being directed to the area that was most likely to provide a positive result. During the middle two weeks of March, an intensive series of door-to-door visits were carried out by Brett and his supporting team, this encompassing all those living in the vicinity of St Paul's, Eastgate, Northgate, North Street and the four possible roads that Vera would have walked along. Upwards of 1,200 statements were taken.

Almost certainly, Vera's murderer was among those interviewed. But by that time it was too late. Memories were fading and certainty of who was where

METROPOLITAN POLICE TELEGRAM.

26th day of February 192 4

From Supt. Brett, Chichester, (Chichester 174),

rwarded at

To New Scotland Yard.

Received at 9-15 p.m.

Missing from her home at Chichester since 6-30 p.m. 25th., Vera Hoad, age 12 (looks older), medium build, fair complexion, hair bobbed; dress nigger brown coat, geranium colour velvet hat trimmed black, black shoes and stockings, blue scarf, may have in her possession a black music case. Will you please cause her name and description etc., to be circulated in your Informations and Police Gazette. Her photograph will appear in the Daily Newspapers tomorrow.

(Sd) A. Davey, Inspr.

Wired to A.S.

The telegram sent by Inspector Brett to New Scotland Yard, asking them to circulate a description of the missing Vera Hoad. (National Archives, MEPO 3/1603)

and who might have verified them being there was beginning to lack clarity. However, in my own re-examination of those same accumulated statements, it becomes clear that one particular individual should have received a great deal more attention. This was a young man, a near neighbour and a definite acquaintance of Vera, who was very unconvincing as to where he was on the evening of the abduction and murder. In two separate interviews, he gives conflicting accounts of his whereabouts. There is, however, one thing that is certain: he was not at home on the evening of the abduction. Furthermore, and from what others reported, he certainly had a habit of befriending young girls well below his age.

While this individual may not have been connected with the horrific murder, the lapse of time in directing the enquiry towards those who lived in the city, ensured that he, or anyone else, could easily have disposed of any soiled clothes or any other incriminating evidence. As for likely injuries sustained, these would also have healed by that point in time. When it came to interviewing the 250 soldiers at the barracks, all were medically inspected. As regards those living in Chichester, no such action, even if it had only involved those failing to provide a watertight alibi, was considered.

As for the pressure on George Hoad this was now taking its toll. Having given evidence during the first stage of the inquest held on 29 February, he was unable to appear at the resumed inquest on 5 March. Shortly after, he appears to have suffered a heart attack that had been brought about by the tragedy. Paralysed on his left side, he was also unable to attend his daughter's funeral held at St Pancras church and which preceded her interment at the municipal cemetery. In concluding the burial service, the Revd J. R. Henderson, dramatically raised his face heavenward and exclaimed, 'We have here an example of the depths to which man may fall away from God and how the Devil can take possession of us all'.

That following Christmas, Eva Hoad, the girl's mother, now a confirmed invalid and wheeled about in a bath chair, gave vent to her frustrated feelings of anger. Desperate to do something that might lead to the finding of the murderer, she sent an open letter to her daughter's killer. Pouring all her sadness into her penned words, she wrote, 'I am asking you to try and picture in your mind how empty of heart's peace and joy our home is at this time... Oh murderer, she was the joy of my life!'

Elsewhere she added,

> This has been a week of agonising pain to my soul; everything I do for the coming season of Christmas-tide reminds me tenfold of her sweetness and your dreadful cruelty.

Wishing to understand just how her daughter had been lured away, she even asked that the killer write to her, 'to tell me how you got her there,' for this at least 'would be some satisfaction'. To these sad and poignant words there was no response – only silence. It is a silence that continues to this day.

At the inquest Detective Superintendent Brett had made it clear that he would not finish his inquiries 'until we get the man'. But this proved an unfulfilled promise. Because of the direction he had taken the inquiry and his inability to read some of the clues, the murder and violation of Vera Hoad remains unsolved. If handled differently, it is likely that an arrest might well have been made. Talking to a wider cross-section of the community could well have unearthed a vital clue. While it cannot be proved beyond doubt, the few clues that do exist seem to point to Vera Hoad's abductor being a person with local knowledge. These same clues also point to someone who could easily blend in, rather than being someone new to the area and with little knowledge of Chichester and its more secluded and darkened corners.

'IT'S VERY PIERCING COLD, ISN'T IT, MISTER?'

In pursuing a major criminal investigation, those responsible for determining the direction of such enquiries are frequently trapped into making assumptions that later hamper their progress. In the case of the failed Vera Hoad investigation, it was incorrectly assumed that the perpetrator had only a limited connection with Chichester. Similarly, in 1935 another assumption led, without sufficient evidence, to the arrest and trial of a young mother for the murder of her five-month-old baby.

It was a sensational case in more ways than one. Between January and March 1936 the local *Observer* newspaper had successfully increased its sales through a series of shock headlines that included 'Baby's Body Found in Canal', 'Mother for Trial on Murder Charge' and 'A Mother Sentenced to Death'. Unfortunately this was a newspaper that chose to sensationalise a sad family tragedy. Furthermore, it was a tragedy that, as it ultimately turned out, was appallingly mishandled by the county constabulary.

Despite that first set of headlines, the real sensation was yet to come. At the end of March, the mother of the child having been sentenced to hang was released from Holloway Prison, her conviction entirely revoked. In reconsidering the evidence, the Court of Criminal Appeal decided that this was the only action open to them. To the three judges who sat in this session, the proof of her having intended to commit murder was not as strong as it should have been. A major factor in her being found guilty was the medical evidence, this demonstrated to be completely flawed. As it happens, it was also a decision of historic importance. Not since 1908, when the Court of Criminal Appeal was first established, had it ever secured the release of a woman condemned to death.

The canal to which the *Observer* headline of 1 January 1936 had referred was that of Chichester, this running from the south side of Basin Road through to Hunston and then on to Chichester Creek. Two young scholars of the Boys High School, George Nuthall of East Street and Peter Seward of the Hornet,

A modern-day view of the canal bank along which Ellen Harding admitted she had walked.

discovered the body shortly after 4 pm on 23 December. It was an extremely cold day; with a bitter north wind driving most people quickly back into the warmth of their homes. The two boys however, were braving the bitter conditions to walk their dog along the towpath. At a point about 60 yds distant from the basin they noticed something floating in the canal. They sent the dog into the water to fetch it out, only to discover it to be the body of a small baby. Clearly shocked, they nevertheless had the presence of mind to run across to the county police station, this recently rebuilt and situated on the north side of Basin Road.

From that point onwards, events proceeded at some speed, with Detective Inspector John Widdicombe given overall charge of the investigation. The body was taken to the city mortuary where an autopsy was undertaken early the following morning. More immediately a search of the canal area was undertaken. It was at 5.15 pm, just an hour after the awful discovery, when a crucial piece of evidence was found. Lying alongside the canal, and about 40 yds from where the body had been brought ashore, was a clean dry packaging label that had at one time gone through the post. Carrying the name of the Universal Chemical Company of Leicester, it had been sent to a certain John Harding of Muir Road in Maidstone.

At this stage, of course, the significance of the address label was unknown. However, the address in Maidstone was visited that same evening, a member of the Kent Constabulary calling on that particular house. Here, Mrs Ellen Steel, owner of a small boarding house revealed that John Harding, his wife Ellen and their four children had, that same morning, departed for Chichester by train. She also revealed that they had been planning to spend Christmas with John Harding's sister who lived in Oving Road.

The Hardings having a connection with the dead baby was now emerging as a real possibility, especially when Mrs Steel revealed two further pieces of information. First and foremost, she indicated that one of the children, a baby christened Neville, was approximately the same age and sex as that of the baby discovered in the canal. She further confided to the visiting police officer, that the baby had caused problems for her recent guests, with determined efforts having been made to get it adopted. To provide potential confirmation that the Harding's baby was the one found in the canal, Mrs Steel was asked to travel to Chichester that following morning to formerly identify the body.

In the meantime, the address in Oving Road where the Hardings and their four children were to have spent Christmas was relayed back to the police in Chichester. This resulted, at approximately 8.30 pm, in Widdicombe himself calling upon the address where the Hardings were due to spend Christmas. In fact, what he discovered confirmed suspicions already emerging, for it was clear that only three of the four children had arrived at the house. In fact, John Harding's sister knew nothing of a baby, having never been told of the fourth child, even though Neville had been born in July.

The police station to which both Mr and Mrs Harding were taken that same evening was the same one to which the two school boys had quickly reported their gruesome discovery. Statements were soon taken, with Ellen Harding readily admitting that her baby had fallen into the canal and that she had singularly failed to recover the child. Leading to police suspicions that she had deliberately murdered the infant was that she simply having walked away from the spot, rejoining her husband at her sister-in-law's house.

At that time suspicion also fell on the husband, it being noted that he seemed singularly unexcited about his wife having arrived at the Oving Road house without their young baby. In time, this was to be explained by his wife having told him that she had finally met someone who had agreed to adopt the baby. As implausible as this seemed, the police were eventually forced to release him, but not until several weeks had elapsed.

Both the Hardings, who were, of course, now in police custody, had strong Chichester connections, the couple having been married at Sidlesham in 1931.

Ellen Harding herself, whose maiden name was Butcher, had been born in Chichester in December 1904 and was the sixth child of a family of seven. She had attended the Lancastrian Girls' School until aged fourteen and, by 1928, was employed as a waitress at Laurie Kimbell's in North Street. It was while working here that she first met her future husband. Following the marriage, John and Ellen appear to have moved around a great deal, eventually coming to Maidstone in the early summer of 1935.

At the time of the two of them moving to Maidstone, John Harding was working as a door-to-door salesman for the Universal Chemical Company, selling a patented chimney cleaner. The items he sold were sent to him through the post, with one of the address labels having been screwed up by Ellen Harding and left alongside the canal bank. In earlier times, the couple had developed a very different way of acquiring money, either stealing from churches or from elderly women who attended church. Their particular method of operation was to attend a service on Sunday, with one sitting in front of their victim and the other behind. At an appropriate moment, the victim's handbag would be taken and quickly passed to the other. This, on a number of occasions, ensured they were not caught. However, in March 1935, Ellen was brought before the police court in East Grinstead where she was placed in prison for a day. Her sentence should have been considerably longer, but it was reduced on the grounds of her being pregnant. It was shortly after that that the couple moved to Maidstone where she gave birth to Neville.

It is upon the actions of a woman who has just lost a baby in tragic circumstances that it is now necessary to direct attention. Ellen Harding, who may have been in the throes of post-natal depression, found it difficult to defend her actions. Seemingly she had made no attempt to rescue the child, call for assistance or report the tragedy. While there is the possibility that she had entered an unreal world of her own in which panic had led to the freezing of her mind and a fear of the consequences in admitting what had happened, this was not something that the police would countenance. Instead, they assumed only one explanation, that of Ellen Harding having murdered her own child. In doing so, the evidence that now began to be collected and was carefully, although probably unwittingly, massaged to produce support for such an assumption. This is clearly demonstrated by the statement that Ellen Harding was encouraged to provide at an unreasonably late hour on the night of her detainment at Chichester Police Station.

In this statement, unaccompanied by either a solicitor or independent witness, Ellen Harding placed herself in an indefensible position, making several declarations that showed her in a most unfavourable light. Putting these aside for a moment, it is of value to first consider the words marshalled

A police photograph of the canal taken at the time of the investigation into the death of baby Neville. (National Archives, HO144/20214)

in her statement and which she subsequently signed as being a true version of events that had taken place.

> I went along the canal bank and sat down on a seat and became rather worried as to if this person would take the child. I became rather giddy and faint and when I had fed the baby I fainted right off. When I came to I missed the child and looked round for it.

> I never dreamt that I should find it in the water. It was such a shock. I suppose it had rolled into the water. When I realised where it was it frightened me, and I was afraid to tell my husband.

> When I came to I saw the baby in the water. I did not tell my husband what had happened to the baby and he did not ask me. I got home about five o'clock and he knew nothing about it.

Having arrived at Chichester railway station shortly after 3 pm, the Hardings had separated. While John Harding had gone directly to his sister's house,

The seat upon which Ellen Harding had been sitting on that cold winter's day in December 1935. (National Archives, HO144/20214)

Ellen had promised her husband that she would visit the person who she thought might take the baby. She later said that it had been her intention to ask this person to take the baby for a few months, or at least until they were better positioned to look after the child. In particular, they were not welcome to return to their Maidstone lodgings, being under threat of eviction. This had followed on from the birth of Neville, Mrs Steel believing that the two rooms they occupied were inadequate for such a large family. Admittedly, the eviction notice had been in place for six months, but the landlady was getting increasingly impatient with them.

However, there does also appear to have been a darker reason for Ellen attempting to get the baby adopted. She needed to do so because of her husband who had clearly rejected the newborn child, believing it not to be his. While never publicly accusing his wife of being unfaithful, he frequently proclaimed that not only was the child unplanned but that it was not possible for his wife to have become pregnant. The increasingly despondent Ellen Harding occasionally confided all this to Mrs Steel. 'Jack won't keep the baby,' she told her on one occasion. 'It's drifting us apart.'

Sometimes, she claimed, her husband also beat her, with Mrs Steel being shown bruises on her leg. As for her husband's attitude to the baby, Mrs Steel had some very real concerns. In the evenings, when Ellen took time out to visit the cinema, he rarely attended to its needs, ignoring the baby when it cried. On one occasion, he even slammed down the lid of the trunk in which the baby slept in and as if to suffocate him. When Mrs Steel queried the action, he said it was only to drown out the noise of the baby crying.

In an attempt to get the baby adopted, Ellen arranged for the placing of three adverts on 6 December. Two of them appeared in shop windows, including a children's outfitter, while a third went to a local newspaper, the *Kent Messenger*. Annie Wheeler, a clerk at the newspaper's Maidstone office, would not at first accept the one offered to them because it contained a box number. At that time it was their policy only to accept advertisements for the adoption of children if it contained a full address. As accepted the final wording read as follows:

> Will some kind person adopt a nice, healthy baby boy, for love only, within a fortnight – apply Mr and Mrs Harding, 10 Muir Road, Maidstone.

And this is where the evidence begins to move in favour of Ellen Harding not having murdered her young baby boy. It is also this evidence that was particularly downplayed by Widdicombe in his investigation into the death of her five-month-old son.

First and foremost, the baby, as the advertisement indicated, was definitely healthy, with absolutely no indication of it having been neglected in any way. Indeed, there are doubts as to whether Ellen Harding really wished to have the baby adopted. It is possible that she had only placed the advertisement to please her husband. Mrs Steel, on seeing the advertisement in the following day's newspaper, most certainly expressed surprise that Ellen was seeking out someone to adopt the baby, believing that her lodger very much loved all her children. 'I can't understand', said Mrs Steel addressing Ellen Harding, 'why you are wanting to part with the baby'. 'I don't want to part with it', Ellen reportedly replied. 'And I am not going to'.

On the day that the Hardings left for Chichester, Mrs Steel again raised the question of the baby, wondering if there was still an intention to have it adopted. While she did not believe there was the slightest possibility of Ellen Harding killing the child, she did wonder if there was a plan to abandon the child for someone else to find. Again, she probably believed that if such a thought existed, it emanated from the father rather than the mother. 'What are you going to do with the baby?' she inquired. 'We are taking it with us', Ellen

Harding replied. 'If you dump that baby', Mrs Steel declared. 'I shall be hot on your trail this end'.

Just as the couple were leaving the landlady asked one small favour. 'Let me kiss the baby for the last time'. It was an ambiguous remark and one Widdicombe later viewed as evidence of the Maidstone landlady believing that murderous intent was possible. As a result, he chose to include it in his later summary of the investigation. It was also used in court to strengthen the evidence against Ellen Harding. However, it was later withdrawn when Mrs Steel explained that it referred to the family leaving her lodging house, with Ellen Harding having already made it clear that they would not be returning to Maidstone.

Looking back at Ellen Harding's statement, made on the evening of her arrest, it might be noted that she indicated that while sitting on the seat that overlooked the canal, she actually fed the baby. It was made as a passing remark, 'when I had fed the baby', and did not carry the weight of a direct statement. As such, it was easily ignored, and was not investigated further. Yet it should have been. Ellen Harding here portrays herself as a loving mother who placed her child to the breast and proceeded to feed it despite any discomfort to herself brought on by a bitterly cold north wind to which she was exposing herself. Surely, this was not the action of a mother about to kill her child? Furthermore, if there is any doubt as to her taking this action, it is only necessary to look at the autopsy report for confirmation. In his report, Dr Anthony Barford, the same police surgeon who had examined the body of Vera Hoad, stated of the young baby that 'the stomach disclosed recent milk feeding'.

A number of passers-by saw Ellen Harding seated next to the canal and expressed surprise at her being there, it being extremely cold. Among them was William Bryant, a Chichester Corporation employee, who came across her at around 3.50 pm. He was concerned for her general wellbeing, feeling that she should have been sitting cosily at home, rather than seated alongside the canal in such harsh weather. According to Bryant, in a statement he later gave the police, he noted that she had a handbag with her and from which she took out a piece of paper. He further noted that she was 'all of a fidget', appearing ill at ease. 'Where's the pram today?' he threw in her direction as he walked past the seat. 'I have not got one,' came the reply. 'It's hard work,' he continued, 'carrying a youngster along'. 'Yes,' she concluded.

In reviewing Bryant's declaration that Ellen Harding was ill at ease, this was open to various interpretations. From the point of view of those seeking evidence that she was contemplating the drowning of her baby, it was a clear sign that

she was on the verge of carrying out that horrendous act. As for the evidence of her being fidgety, this was based on her standing up and then sitting down again. Conversely, of course, it could easily have been the sign of a woman who was anxious about returning to her husband with the unwanted baby.

A possible scenario for her actions that afternoon was not that she was either about to drown the baby or even take it to a friend for adoption. In fact, it seems unlikely that such a friend existed, no further evidence being offered by Ellen Harding to support such a contention. Much more likely, and conforming with exactly the same evidence that Widdicombe assembled, was that she had invented this friend as proof to her husband that she was serious about getting the baby adopted. This, if nothing else, would buy her time in the hope that he would come round to accepting this last addition to their family. On returning to her husband, now at his sister's house, she would simply claim that either this fictional person had refused to take on the baby or that thought was still being given to the matter. Either way, it might be sufficient to placate her husband and delay any future beating that she might have to undergo.

If it had been her intention of throwing the child in the canal, then more might have been done to conceal the identity of the child. After all, her sister-in-law in Oving Road knew nothing of the fourth child and the Hardings had made it clear that they were not returning to Maidstone. It would therefore have been conceivable for the perpetrator of such a crime to go undetected. Yet, in a matter of four hours, the Hardings were under arrest. And the reason this had come about was that of her having left at the scene of the crime a vital piece of evidence – an address label. For such a carefully planned crime – for that is what it clearly appeared to Detective Inspector Widdicome – then this mistake would simply not have been countenanced. According to Ellen Harding, 'I screwed some brown paper up after the baby had fallen in the water but I do not remember where I threw it'.

Much was made of the way that Ellen Harding chose to journey from where the child had died to her sister-in-law's house in Oving Road. The most obvious route was along Basin Road and Market Avenue. However, this would have taken her past the newly constructed police station, a building it was assumed that she wished to avoid. Instead, and for this reason it was suggested, she deliberately chose a much longer walk – a walk that took her along the canal path to Hunston before returning into town via the Selsey Road. Equally, of course, such a lengthy route could also be explained as resulting from an unhinged state of mind that had descended upon an already depressed and grieving mother.

While walking along the canal path, and as she approached Hunston Bridge,

she was also seen by Alfred Smith, the canal keeper. On this occasion, Ellen Harding was the one who threw out a passing remark and one she might later have regretted. Instead of drawing attention to her lost child, she commented instead upon the weather. 'It's piercing cold, isn't it, mister,' she called out. The canal keeper carried on with his work, simply agreeing. In a statement later made to Widdicombe, Smith confirmed that Ellen Harding had offered nothing more and certainly failed to say anything about her lost child.

According to her sister-in-law, both the Hardings acted quite normally during the early part of the evening with nothing said of the fourth child. Instead, they went out during the early evening, going into town where Ellen Harding bought some nuts for the children. Upon their return, and following the children going to bed at 8 pm, the conversation that ensued was quite natural and relaxed. The Hardings, both of who were familiar with Chichester, began to comment on changes taking place in the city. 'When they build the new cinema,' remarked Jack, referring to a Gaumont cinema planned for Eastgate Square. 'There'll be three.' 'No,' replied his sister. 'They are closing one down.' 'That's what I'll miss,' added Ellen. 'We go to the cinema three or four times a week.'

It was approximately 8.30 pm that Detective Inspector Widdicombe made his move, personally calling at the house in Oving Road. Already convinced that he had as good as solved the case, his thoughts were instantly confirmed by Ellen Harding making no attempt to deny that it was her child that had been found in the canal. Furthermore, she made a considerable effort to remove any suspicions that might also have fallen upon her husband. In her statement she made this quite clear, telling Widdicombe that 'he knew nothing about it'. This was a point she re-affirmed that following morning when both of them were formally charged.

'He didn't know a thing about it,' she called out. 'You have got the statement I made last night.'

'I am not guilty of the charge,' confirmed John Harding. And to this he later added, 'I object to the remand. I was living at my sister's address at the time, and I knew nothing about what had happened until hours later.'

However, while her loyalty to him remained unbroken, the same could not be said of him. In realising that he, himself, was now facing a murder charge, John Harding did his best to shift the blame entirely upon his wife. While being taken to Lewes prison by train and under the escort of Police Constable Sutton and Detective Constable Eagle, he proceeded to make a number of serious allegations against his wife. While not used in court, they would most certainly have helped cement Widdicombe's belief that she had very definitely murdered

A modern-day view of the section of the canal where baby Neville died.

her child. John Harding's remarks were carefully chosen, as they also went some way in questioning her morality.

'It's a mystery how it came,' he remarked, suggesting that the child was not his. 'And its been a trouble ever since. Mrs Harding was agitated all day but I didn't think she would do it in.' At this point he was cautioned, warned that anything he said might be used in court. 'I am telling the truth but it's only natural I didn't want to do anything to harm her.' he continued. 'I thought it funny coming down in the train, she wanted to go to the lavatory several times and wanted to take the baby with her. I believe she would have chucked it out of the window if I'd have let her have it'.

At her trial, held in March at the Lewes Assizes, it was the medical evidence given by Dr Barford that proved crucial to Ellen Harding's conviction. It was based on the autopsy he had undertaken on the morning of 24 December. He began with a statement of the child having been in good health, a point that should have carried in the mother's favour. He also noted that the child had been recently fed, but did not dwell on this point. As to the cause of death, he indicated that Neville Harding had died from heart failure due to the shock of sudden immersion in cold water. At the earlier magistrate's court hearing in January, this point had already been teased out.

'I do not think death would have resulted if the baby had rolled into the water', said George Paling appearing for the Crown. 'The shock of the immersion would not have been sufficiently severe to cause heart failure.' And, this fundamentally was the pillar upon which the evidence for Ellen Harding's conviction really stood. Everything else was circumstantial. Whether she had planned the baby's death or had really intended to have the boy adopted or returned to the family home, could be nothing more than surmise. But this was different, appearing as clear evidence of the baby having been thrown into the water rather than simply rolled off the mother's lap as a result of an uncontrolled faint.

It was this same evidence that was also accepted at the Court of Assize, with no doctor being called by the defence to question any of this. From this point of view, of course, the trial was inherently unfair. The barristers working for the director of public prosecution were well funded and able to bring in any specialist evidence that they might choose. Ellen Harding, on the other hand, had only recourse to funding under the Poor Prisoners Defence Act, this being set at a miserly level that did not allow the possibility of calling an expert medical witness who might have questioned the evidence put by Dr Barford.

The judge, faced with this evidence and the decision of the jury had no option but to pass the death sentence. While the jury pleaded for leniency, the rulebook was clear. She had taken a life, so her life must also become forfeit.

Indeed, Ellen Harding might well have been executed if it had not been for the interest in her case taken by Dr John Mathieson, the Governor of Holloway prison. A doctor of medicine with an interest in forensic science, he was present at her trial and had listened carefully to the evidence presented. While he could not comment on much of the circumstantial evidence, he did feel that something more needed to be said about the conclusion presented by Dr Barford, as the more he looked at the evidence, the more he began to doubt its reliability. He noted, from his presence at the trial, that Harding's conviction more or less totally relied upon an understanding that the baby died from shock resulting from sudden immersion into bitterly cold water. In this being accepted, it led to a further understanding that, for the baby to have fallen into a sufficient amount of water for this to have happened, then it would have to have been thrown into the water with some force. It was the putting together of these two assumptions, combined with Ellen Harding's extraordinary behaviour after the child had fallen into the water, that had led to the jury finding her guilty.

In his examination of the medical evidence, Dr Mathieson contended an alternative possibility. He considered that it would not have been necessary for

Ellen Harding (centre right) holding her son. Others in the picture are her mother and niece.

the child to be immersed in a large amount of water for death to occur. Instead, it was only necessary for a few drops of water to be ingested into the nose for death to have occurred. Furthermore, Mathieson contended, this was the more likely cause of death on this occasion.

In making this observation, Mathieson was about to turn the entire case on its head. In her defence, Ellen Harding had claimed that the child had rolled off her lap. If it had done so, it would have fallen into an extremely shallow area of water rather than the deeper stretch in which it was later found. According to the prosecution, if this had occurred, the baby would not have died but would have begun screaming and crying. Therefore, based on the uncontested evidence of the police doctor at her trial in Lewes, Ellen Harding must have deliberately thrown the child into the canal.

Now, it was being suggested otherwise. Furthermore, if Ellen Harding had fainted and the child had rolled into the water then it began to make sense of

some of the other evidence given. First and foremost, it should be remembered, that Ellen Harding did not appear as if she really wished to part with the child and may not really have wanted to hand it over for adoption. Secondly, there is considerable evidence that she was meticulous in looking after the child, keeping it well nourished, clean and healthy. Only two weeks prior to the tragedy she had even arranged for it to be vaccinated against smallpox. This was another piece of evidence revealed in the initial medical report but quickly brushed over by the police surgeon. Furthermore, while sitting alongside the canal Ellen Harding had even breast-fed the child, despite plummeting temperatures.

Having reached a very different conclusion to that of Dr Barford, Mathieson was given permission to appear at the Court of Criminal Appeal when it reviewed the evidence against Ellen Harding. In listening carefully to Mathieson's findings, Lord Justice Hewart, the senior judge in the hearing, made his views quite clear. He considered that if the evidence as presented by Dr Mathieson had been available at Harding's initial trial, a reasonable doubt would have been created. Agreeing that it had been the medical evidence that had decided the matter in the minds of the jury, Hewart quashed the conviction as being unsound. In doing so, he immediately secured the release of Ellen Harding.

This final and sensational turn of events was also reported on the front page of the *Chichester Observer*, but on this occasion it was not a headline story. Instead, the paper was slightly muted and avoided highlighting it with anything more lurid than that of 'The Chichester Baby Case'. However, the newspaper did ensure the presence of its own reporter when Ellen Harding returned to Chichester to collect one of the children that had been living with her mother. Managing to get an interview with her, he recorded her general feelings of relief that the ordeal was now over. 'How nice it is to be back in these parts', he recorded her as saying. Later on she further added, 'I never quite expected to be sentenced to death. The judge looked so stern when he put the black cap on.'

The release, of course, quite naturally attracted the national press as well. At first, Ellen Harding managed to avoid falling into their grip, smuggled out of Holloway Prison through the nurses' entrance. From there she was swiftly taken to Seaford before returning to Chichester. Somewhere on the secret journey, a *News of the World* reporter intercepted her,

'I can't believe it's true. It has been a long nightmare,' she told this particular journalist. 'I have been under restraint since Christmas Eve. Now I can do as I like and that makes even buying a box of matches a joy. When I learned that my conviction had been quashed the strain was too much for me. I broke down and cried like a child.'

The newly built county police station where Ellen Harding was taken upon first being arrested.

Strangely, it was also reported in a number of newspapers that she had a loving and joyful reunion with her husband. I use the word 'strangely' because of her husband having tried to ensure his own freedom through the telling of a certain event to his two escorting police officers when on his way to Lewes Prison. It is even possible that his account of his wife's behaviour on the journey from Maidstone to Chichester was entirely false. After all, he was a man who was desperate to avoid a murder rap and had not the courtesy to at least protect his own wife. That there was, in fact, a subsequent divorce should come as no surprise.

At the outset of this account it was suggested that the inquiry into the death of Neville Harding was seriously mishandled. This was certainly not the view of those in Chichester who were connected with the enquiry. Within the pages of the police file held at the West Sussex Archives Office is an intriguing letter written to those conducting the investigation and signed by William H. Butt, the district superintendent. In it, he forwards comments on the investigation made by magistrates following the presentation of final evidence relating to the case. In his letter, Butt wrote,

I beg to report that the police court proceedings, in connection with the above, were concluded at Chichester City Petty Sessions today [10 January 1936],

William John Harding being discharged and Ellen Harding committed for trial at the next Assizes.

At the conclusion of the hearing the Chairman of the Bench, A. F. Lewis, esq., said: I have been asked by the Justices to say how impressed they have been with the manner in which this case has been got up and presented in the court.

Yet, with the inquiry failing at the last hurdle, it demonstrates that neither the local magistrates nor those responsible for this investigation had really done their homework. In particular, Dr Lawson, the police surgeon, appears to have got it completely wrong. Being directly employed by the Sussex Constabulary, it is hardly surprising that his evidence would meet the requirements of an on-going investigation that had as its one objective the discovery of evidence that would condemn Ellen Harding. Known by modern-day criminal psychologists as confirmation bias, it ensured that all evidence that favoured the suspect was either ignored or discarded. Given that it could lead in only one direction, the sentencing to death of the woman accused, then the investigation should have been more thorough. An expert should have been brought in. This they chose not to do – for as far as Widdicome was concerned, the woman was guilty and there was no possibility of it being considered otherwise. In other words, to repeat my opening words, the investigators had been trapped by their initial assumption and their minds closed to any alternative possibility.

MURDERERS AND BLACK MARKETEERS

Chichester, as a city, survived the horrors of the Second World War relatively unscathed. It was certainly the subject of a few air raids, with casualties resulting, but these were limited when compared with those inflicted on nearby Portsmouth during the winter of 1940-41. However, the city found it a lot more difficult to avoid the massive social upheavals that were also a major feature of those wartime years.

Throughout Chichester, families were split apart, with husbands, wives, sons and daughters called upon to undertake wartime service. In addition, the city, during the first nine months of the war, was also a major centre of evacuation, with many from London sent to Chichester for their own safety. This also placed a strain on the area, with families from two different worlds often forced to share a common roof.

A particular feature of these wartime years was a massive increase in crime. The *Chichester Observer*, in reporting a weekly list of offenders brought before the local magistrates, was recording a far greater number of felons than it had reported on during peacetime. In part, this was because there were more laws to be broken, an endless number of people fined the statutory five shillings for allowing a chink of light to be shown during the blackout or failing to produce an identity card. In addition and through the introduction of rationing, the buying and selling of controlled goods, known as black marketeering, was another crime that directly emerged out of the war.

Yet, the increase in crime was not purely and simply a product of new regulations. A closer scrutiny of cases brought before the courts showed a very definite increase in crimes against property, especially of forced entry into vacant houses. In 1941, breaking and entering had reached epidemic proportions, these seemingly fuelled by the large number of soldiers brought into the area and having little to occupy them. The Chichester Quarter Sessions held during the summer of that year had twenty-six soldiers facing trial, the

majority accused of breaking into local houses, garages and hotels. As for the suggestion that the cause was boredom, this emanated from a Canadian officer who, in supporting one of his soldiers in the same court room, said of his men in general, 'they are getting bored and don't want to sit down in England for a long time, it is not our fault that we have to sit down'.

With regard to black marketeering, this might be seen as a fairly harmless activity, permitting the occasional individual to acquire small luxuries that they might have otherwise gone without. Unfortunately, this was not the reality of the situation. Instead, black marketeering was dominated by highly organised gangs that frequently stole the commodity that was to be marketed while rarely hesitating at the use of violence to ensure the success of their endeavours. Petrol, in particular, was a commodity frequently sold on the black market, it being unavailable to the private motorist. Even legitimate businesses found it difficult to acquire sufficient for their needs, with the rationed amounts allowed reduced as the war continued. In August 1940, a gang based in the Chichester area began to specialise in the sale of petrol that had been stolen from Tangmere airfield. The importance of this fuel for the defence of the country and the massive cost of human life associated with its importation ensured that the courts had little sympathy towards such felons.

The gang concerned were all members of the armed services and were based at Tangmere airfield. Over a six-month period during the early part of 1941, they stole over 700 gallons. In towns as far away as Epsom and Redhill, together with nearby Bognor and Chichester, they found a number of willing purchasers. In Bognor, it was the owner of a local bakery who made purchases from the gang, claiming that he needed it to keep his delivery vans remaining on the roads. As for the nine members of the gang brought before Chichester Police Court on 12 August, two of them received hard labour and the rest were heavily fined.

Later, in October 1941, a second gang selling motor fuel on the black market was uncovered. On this occasion it was taken from a fuel store at Thorney airfield and was owned by West Sussex County Council. At the time, the council had been contracted to undertake an extension to the airfield, with an estimated 138 gallons of fuel being illegally removed from the site. Those involved were mainly drivers of dumper trucks who were siphoning off unused fuel at the end of the morning and evening work sessions. Allowed to draw five gallons each morning and a further five gallons in the afternoon, this was the presumed amount needed to carry out a day's work. In theory, at the end of a work session, each truck should have been virtually dry. However, the drivers

had begun to deliberately work at a slower pace, ensuring that less petrol was being used and so leaving at least a gallon at the end of work sessions for each driver to procure. That they were detected was a result of the drivers seeming to achieve less work over a period of time than had been allowed for. Once again brought to the Chichester Police Court, a mix of prison sentences and fines were handed down.

Looting of bomb-damaged property was less likely to be organised, being more the product of opportunity. In Chichester, such a chance rarely arose, the city only being bombed on three occasions. Yet, when the opportunity was there, then the city showed that, within its midst, were those who were prepared to take advantage of the suffering of others. Following the most severe raid, that of February 1943, at least one person was involved in the removal of salvaged property from one of the more severely damaged houses in St Martin's Street. Brought before the police court, the individual concerned was fined £2 having, in the words of the presiding magistrate, carried out 'a very despicable action'.

An earlier case of looting had also occurred in May 1941 when a crashed German aeroplane had its fuel removed by a number of West Wittering inhabitants. Among them, somewhat surprisingly, were a doctor and a farmer. I say surprisingly, as both were permitted petrol coupons at a sufficient level to carry out their respective professions. Both were brought before the police court in Chichester where the magistrates fined them £12 each. This was a fairly lenient sentence as it was possible to impose a fine of £100. In their defence, both acknowledged they had no need of additional fuel but claimed simple inquisitiveness as their reason. In taking the fuel from the crashed German aeroplane they wanted to compare its efficiency, when placed in a car or tractor, with that sold in Britain. In handing out such a small fine to two reasonably affluent individuals, it seems the magistrates may have bought into this excuse. Before concluding the matter, Superintendent Edward Savage, who had been involved in the enquiry, was asked to take forward a message to the Ministry of Defence. It was a request from the magistrates of the court that when an aeroplane crashed and survived relatively undamaged, then a permanent military guard should be established. Apparently, this particular aeroplane, a two-engined bomber with 370 gallons of fuel on board, had been given a military guard for only two days. Once the guard had been removed, it was an easy task for local residents to take both petrol and souvenirs.

Edward Savage was Chichester's leading crime fighter during these wartime years. The senior member of the detective branch, he was immediately

responsible to the chief constable. His area of responsibility not only included the city of Chichester but also the surrounding rural area and a number of the seaside towns to the south. He was a significant player in all of the major criminal investigations that took place in the Chichester area during this period. Indeed, if fact was allowed to mingle with fiction, then he was very much Chichester's equivalent to Detective Chief Inspector Christopher Foyle of the popular television series.

An alleged case of spying was brought before the Chichester City Quarter Sessions in October 1941. Earlier that summer, with Britain desperately fighting for its survival, George Edward Anderson, a forty-one-year-old aircraftsman attached to the RAF at Tangmere, claimed that he had been asked by a stranger to divulge a number of military secrets. According to Anderson, this had taken place on the evening of 27 August, while he was drinking at the Old Cross public house in North Street. Wishing to bring the matter to the attention of the police, Anderson had soon after left the building and flagged down a passing police car. This, as it turned out, was the beginning of a manic thirty-hour search for a non-existent fifth columnist.

On arriving at the Basin Road county police station, Anderson immediately informed the desk sergeant that he had been approached by a man who had asked him a series of questions as to where he was based and what he knew of local military defences. Immediately, of course, the matter was passed to Edward Savage, with the Royal Air Force also informed. Within an hour, Anderson found himself telling the same story to Savage and an RAF intelligence officer, this time his words recorded for a signed statement,

> I saw a man in the Old Cross who asked me a lot of questions – funny questions – about my job. He asked me how far away it was, how long it took me to get there, and where I worked. During the conversation I suspected him and asked him to show me his identity card. He produced an identity card, which was marked in indelible pencil, 'A. G. Phillips, Crofton Hill, S.E.5.' I took this down in my pocket book.

What Anderson told his two interviewers was extremely alarming. Maybe the mystery man was a German agent, or even a saboteur. Worse still, he appeared to have been in possession of a map that indicated the site of a number of gun batteries and the four airfields in close proximity to the city. Anderson continued to relate the events that had taken place earlier that same evening,

We then went out of the bar into the urinal, where we had another conversation, during which he pulled a paper from his pocket and dropped it on the floor. I put my foot on it. He tried to get it back and then ran away.

That Anderson was now able to produce the map seemed to confirm his alarming tale. Well, it did, up to a point.

As it happens, Anderson had embroidered his story just a little too well. Strangely, the map handed over to Savage, showed no evidence of being dropped on a dirty and damp floor nor did it show any signs of Anderson having stood upon it. Quite the opposite: it was clean and neatly folded. A further examination of the map also revealed that it had been taken from a Kelly's directory dating to 1937.

Accepting Anderson's story at face value – or at least until it could be fully checked out – an extensive search to find the supposed spy was immediately ordered. Around the city, roadblocks were established; these variously manned by the police, Home Guard, Army and Royal Air Force. Anyone leaving the area from the direction of the city was stopped and asked to provide identification. Not unnaturally, this caused a good deal of wonderment, with a number of rumours beginning to circulate.

Eventually, however, things began to fall into place. That following morning, Police Sergeant Heslin was instructed to take charge of an investigation into the immediate facts presented by Anderson. Following enquiries at the Old Cross, Heslin slipped across to the Toc H. Club in Chapel Street, where Anderson had been staying. Here Heslin learnt something of particular interest. While changing the bedding in Anderson's room, cleaning staff had come across an out-of-date directory lying next to his bed. The manager confirmed it actually belonged to the club but he also noted that a map that had, until recently, been secured inside the book, had been carefully torn out. Heslin noted that it was a 1937 copy of the popular Kelly's directory.

On re-examining the map produced by Anderson, it soon became apparent that it had been taken from this same directory, the tear in the book providing an identical match. On being confronted with this development, Anderson immediately proclaimed it to be a fair cop – although Heslin refrained from suggesting he used that particular phrase, nor that he ended it with 'guv'ner'. But it was fairly close, with Anderson apparently saying, 'Oh well, I'm for it; I'll take what's coming to me; I'll tell the truth'. With that he was immediately cautioned and taken to one of the four cells that then existed at the back of the station.

A few weeks later, Aircraftman Anderson made his appearance before a surprisingly lenient Judge Havers at the City Quarter Sessions. A rather

stupid act at such a desperate time in the nation's history, Anderson's lies had resulted in an extensive search being conducted throughout the Chichester area, which had used up 1,738 hours of police time with patrol cars covering 301 miles in the search. On top of this should be added a number of additional hours put in by the army and air force together with £1 5s apparently spent on telephone calls. This alone should have ensured a custodial sentence. But Anderson's luck seems quite unbelievable. His commanding officer put in a good word for him, indicating that he was needed for important work at the airfield. The outcome, a heavy fine and considerable embarrassment for a man who claimed he was not in his right mind at the time, being under the influence of alcohol.

Of other high profile crimes, the incidence of murder dramatically increased. During the twenty years of peace between 1919 and 1939 the local constabulary investigated only two suspected murders. In the six wartime years of 1939 to 1945, this number increased to five. With one exception, those responsible for committing these crimes were servicemen who had been brought into the area as a direct consequence of the war. The exception, a murder carried out in the summer of 1944, was that of a husband, albeit a serving member of the Royal Air Force, who had returned to his home in the Broyle where he killed his wife before taking his own life. No serious investigation was required, extensive evidence showing that the man had become increasingly concerned that his marriage was about to end and seemed unable to face life on his own. The war, however, did play its part in two ways. For one thing, the marriage was probably weakened by extended periods of separation. In addition, it also ensured the easy availability of the weapon that brought about the two killings. It was a Home Guard sten gun that belonged to the wife's father and was being kept in the house where the couple met on that fateful day.

Of those murders committed by servicemen brought into the area, two of them had a degree of similarity. Specifically, they involved newly recruited soldiers whose main task was that of driving supply trucks between various nearby locations. In the course of these duties both soldiers, who were otherwise unconnected, came upon females in uniform who they attacked and left for dead. In both cases a considerable degree of violence was used with both of the murdered women being in military uniform at the time of being attacked. A final, and not insignificant coincidence was that of the local police buying in the services of Sir Bernard Spilsbury, the much-acclaimed Home Office pathologist. Of his appearance at the scene of these two murders, more will be said in due course.

The first of these two murders took place in February 1941 and was initially assumed to be the result of a motor accident. Early on the morning of the 21 February, Herbert Pratt, while cycling along the Funtington Road near Sennicotts, came across the body of a young woman. From the uniform she was wearing, he could easily work out that she was a member of the Auxiliary Territorial Service (ATS). Also, there could be little doubt that the woman was dead, in all appearances the victim of a motor accident. On the other side of the road, but fallen into a ditch, was her badly damaged bicycle.

It took a while for Pratt to communicate his findings to the police, Sennicotts being a fairly isolated spot. Eventually, at around 7.15 am, Sergeant Stowe and a constable arrived in a patrol car. To begin with, they also concluded that the woman had been the victim of a road accident, albeit one of fairly horrific proportions. There was a good deal of blood on the road, much of it having oozed from the woman's head, this giving the appearance of having fallen under the wheels of a moving vehicle. However, there were also suggestions of this not having been a simple hit and run, the body appearing to have been moved and carefully positioned on the roadside verge.

At the inquest, held two days later at the Royal West Sussex Hospital, an open verdict was returned. By that time the deceased's identity was known, the victim twenty-four-year-old Lilian Margaret Welch, a married woman residing at West Ashling. Employed on duties within the barracks at Chichester, she had been returning to West Ashling late on the night of 21 February. If the evidence of her broken wristwatch was anything to go by, she had been run down at 9.53 pm. The surgeon who had carried out an earlier autopsy had been Anthony Barford, the same doctor whose evidence at the Ellen Harding trial had become so discredited. On this occasion, Barford provided a brief description of the inflicted injuries, stating that death would have resulted from multiple injuries to the head. He also indicated that other injuries to the body were consistent with the victim having been thrown forward from her bike following a blow from behind.

The search for the vehicle and its driver was made somewhat easier by the limited number of cars and trucks that used this particular road in wartime. Indeed, with but a few exceptions, most vehicles on this stretch of road were military vehicles stationed at Oakwood House. Less than a mile from where the body of Lilian Welch had been found, Oakwood House stood on a side road that led immediately off the Funtington Road. Taken over by the Royal Signals Corps in 1940, a number of drivers were billeted here, together with several heavy lorries.

As in the failed Vera Hoad investigation, police suspicion immediately fell upon soldiers billeted near to the site of the crime, although on this occasion there was more substance to their assumptions. Again, as in the investigation that had been undertaken eighteen years earlier, each man stationed in this sizeable country mansion was interviewed and a note made of his movements and any remarks he made of his comrades in arms. With this work carried out by Police Sergeant Heslin, he soon learned that two of the men in the billet had been on driving duties that evening with Driver William Thomas Flack having returned to Oakwood House at precisely 10.10 pm. When Flack himself was interviewed he denied having been on the particular stretch of road where the body had been found. In fact, he correctly pointed out that in returning from an errand in Chichester, it would have required him driving past Oakwood House to get to the place of the accident with there being no point in him doing this. However, given the timing of his return, he was most definitely a suspect.

Following this brief statement of denial, Driver Flack's billet was searched, with an immediate breakthrough being made. A pair of boots which were found under his bed had stains not dissimilar to blood on the welts and upper leather. Flack could give no good reason for the presence of these marks,

> 'I did not notice the marks when I polished the boots, but I have not worn them here at all,' Flack claimed. 'I last had them on at Tenby where I was previously stationed.'

Heslin took immediate possession of the boots and several items of clothing. In addition, the truck driven by Flack on the night of Lilian Welch's death was also taken into police possession. Finally, Heslin also returned to the site of the young woman's death and collected some sample material. The intention, of course, was to have all these items analysed in a forensic laboratory. At that time, few county forces possessed such a facility, with Heslin starting out on the following day for the Metropolitan Police laboratory in Hendon. His means of transport, of course, was the army truck, with the collected items carefully placed on the left-hand passenger seat.

The noose, if only metaphorically, was beginning to tighten around Flack's neck. However, denial continued to be the order of the day, with Flack refusing to concede that he had been anywhere near the stretch of road where the death had occurred, offering a statement to this affect a few days later:

On the evening of 20th February I volunteered to take the lorry and pick up a signalman Williams at the police station and someone asked me to post a letter. I had to report to headquarters and, on arriving there at 8.30, found Williams was already there. I took him to the WVS canteen and then decided to go into Chichester and post the letter. I had been in the locality two days and did not know Chichester but, seeing a YMCA sign, I went in for a cup of tea and remained there from a quarter to half an hour. I next drove to the WVS canteen in West Broyle Avenue, where I saw three women and a man leaving and was told the canteen was closed. Then I drove back to Oakwood, arriving just before 10 o'clock, and at no time did I drive beyond the turning leading to my billet.

As it stood, Driver Flack was looking at a possible charge of failing to report a motor vehicle accident. In addition, continuing to conceal his involvement in the accident might also be added to any accusations brought against him. Charges of a more substantial nature seemed an unlikely possibility. As a driver of a military vehicle, he was expected to navigate darkened country roads with headlights dimmed. As to the Funtington Road, this was one of the darkest roads in the county, lined on both sides by a number of tall trees. In such a situation, the running down of a cyclist, tragic as it might be, was thought preferable to that of showing lights while the Blitz was still at its height.

Yet, something puzzled Heslin and his superiors. Why did Flack continue to deny his part in the accident? The evidence provided by the scientific analysis of the various items taken to Hendon proved conclusively that Flack's lorry had run Lilian Welch down. Furthermore, the marks on his boots also proved that he had been the one that moved the body. If nothing else, Flack should have accepted the inevitable and owned up to the accident. Yet he stubbornly refused to do so. It was for this reason that the nature of the investigation was pushed out in a different direction. Questions were asked as to the kind of man he was and how he had behaved during his stint of service in Tenby.

Now came evidence of something much more sinister. From enquiries made of the police in Tenby it was soon revealed that at least one woman had accused him of sexual assault. Even more disturbing, and just before Flack had been posted out of Tenby, a woman cyclist had been bumped from behind by an Army lorry. This time it had taken place in broad daylight, with the woman falling on to the grass verge. Not unnaturally, the lorry had stopped and the khaki-clad driver had quickly stepped down. Instead of enquiring as to the nature of her injuries and whether he could assist her in any way, he treated her in a very different fashion. Pulling her over to the lorry, he started to remove some of her clothes before touching her intimately.

The victim of this accident, Eiluned Bridgeman, had given a description of the man and one that closely resembled Thomas Flack. For this reason she, together with Alice Allen, was asked to come to Chichester for the purpose of identifying Flack, the man who, albeit on separate occasions, had attacked them. This they duly did on 5 April, neither having difficulty in pointing him out as he stood among a number of other uniformed men in an identity parade.

Again, Flack chose to deny all, stating that he had never previously seen the two women. Or at least he continued this denial for a number of days. Eventually, on 13 April he chose to make another statement,

> I want to say I was the soldier concerned. I did not interfere with the girls. I admit I asked one for a kiss, and the other I accidentally knocked down, but I did not interfere with her in any way.

But this only added to his problems. In admitting that he had run a woman down while she was riding her bike, Superintendent Savage, the man in charge of the murder investigation, believed Flack was establishing a possible pattern of behaviour – a *modus operandi*. As a result, the running down of Lilian Welch, initially seen as an accident, now appeared to have been a callous and deliberate act. In knocking her off her bike, it seemed likely that his intention was to force himself on her. The impact of the rear shunt may have been greater than he had planned, but the outcome had been her death. For this reason, there was a certain logic to a charge of wilful murder that was now prepared against him. However, it was a dubious decision and one based entirely on circumstantial evidence. It was not impossible, given the total lack of any lighting, combined with Flack's lack of local knowledge that he had accidentally run the girl down.

To strengthen the case against Flack and to at least ensure that the medical evidence was secure, the assistance of Sir Bernard Spilsbury was sought. Over a period of thirty years he had made hundreds of appearances in court, his evidence rarely questioned by those who stood up against him. It would be Sir Bernard's task to carry out a second autopsy upon the body of Lilian Welch, this for the purpose of confirming the findings made by Dr Barford. If it had not been for the failure of the medical evidence in the Ellen Harding case, then it seems unlikely that the local constabulary would have chosen to bring to Chichester the universally acclaimed leading expert in forensic science.

In his subsequent report, Sir Bernard did, indeed, confirm the earlier findings of the local police surgeon. Doubtless, from within the office of

Detective Inspector Widdicombe, who was also involved in the enquiry, there could have been heard a huge sigh of relief. He, more than anyone, could ill afford to allow a second murder charge to fail in the public courts. Having tripped so spectacularly three years earlier, this was his chance to regain his reputation as an untiring and efficient detective who was rightly feared by local villains. However, in continuing to pursue a charge of wilful murder, Savage should have carefully scrutinised every word of the report. For, in confirming the cause of death to have been the result of Lilian Welch having been run down by a heavy vehicle, Spilsbury added one interesting detail that would eventually serve to aid Flack in his subsequent trial. Spilsbury made it quite clear that the body showed no signs of sexual interference. The two senior police officers should have taken this as a warning that the case was not completely watertight.

Seemingly, in continuing to insist on a charge of wilful murder, the local police in Chichester were over influenced by the findings of the Metropolitan Police laboratory. According to Dr Davidson, who analysed the material brought to him, the boots and items of clothing belonging to Thomas Flack were all stained with blood. Although the boots had been recently blackened, there was extensive blood staining found under the right boot. This blood was found to be of the same group as that taken from the roadside and belonging to the dead woman. As for the lorry, the towing shackle on the front was found to exactly fit dents in the rear mudguard and carrier of the bicycle.

However, this was far from being conclusive in a charge of wilful murder, especially as anyone found guilty would be facing certain execution. The jury who would be making the final adjudication as to actual guilt would need to be fully convinced that Flack really had taken a decision to run the woman down. If not, then there was only one other possible conclusion – that of it being an awful coincidence.

As for the position taken by Flack, he at last realised how perilous his position had become and accepted that he would have to admit his presence on the road where Lilian Welch had been struck down. He now offered the only possible defence open to him by now claiming it to be an accident. Whether he was telling the truth or not would be up to a future assembled jury. To Superintendent Savage he now claimed,

The statement I made on 13 March is correct up to a point, and that is where I said I went to the YMCA. Proceeding in a direction west from Chichester I passed the road leading to my billet unintentionally, as I had been there only two days. I was half a mile along the road to Funtington when I came into collision with

a cycle and stopped. I did not touch the cycle with my hands and did not put it over the other side of the road, where I understand it was found. I recognised the uniform as that of an ATS woman. I dragged the body off the road and in doing so my boot was covered with blood. I was confused at the time, and arranged the body to make it appear that an assault had been committed. I then drove to the canteen.

However, by now it was all too late, as his earlier lies had created too much suspicion. The subsequent discovery of his having run into the back of Eiluned Bridgeman's bike was taken as conclusive proof of a more sinister intention.

Flack appeared before Mr Justice Humphreys at the Assize Court held at Lewes in July 1941. His defence counsel had been well briefed and proceeded to demonstrate the unsoundness of the police having brought a charge of murder. The likelihood of it being an accident was strengthened by further evidence that showed Flack had a history of poor eyesight and was not fit to drive a heavy military vehicle.

Following a brief retirement, the jury returned with a verdict of not guilty of murder but guilty of manslaughter. Not surprisingly, the charge of wilful murder had fallen through lack of anything other than circumstantial evidence. But the penalty he received was still severe. Flack was sentenced to seven years hard labour.

If, on the other hand, Flack had immediately owned up to the event that had occurred on the night of 20 February, then it seems unlikely he would even have been brought to trial. It was Flack himself who had created the atmosphere of suspicion and so encouraged an overstretched police force to carry out a thorough investigation into his background.

The second wartime killing of a woman in uniform under suspicious circumstances took place during the late afternoon of Saturday 30 January 1943. The victim, a young aircraftwoman serving with the Woman's Auxiliary Air Force (WAAF) at Tangmere, was found the following day in an open field on the south side of the lane that runs between Waterbeach and Halnaker. The discovery was made shortly after midday on the following Sunday by two members of the Home Guard returning from morning drill. Seeing the body through a gap in the hedge, they at first assumed the blue bundle they could see was that of a service man who was sleeping off a bout of heavy drinking. Approaching nearer, they soon realized their mistake, the bundle concealing a young woman who was, by then, close to death. At some time she had sustained severe head injuries, but they did notice the very slightest signs of movement.

The field alongside the Halnaker to Waterbeach road where Marguerite Burge was discovered on the afternoon of 31 January 1943. (National Archives, MEPO3/2247)

At the time it was raining, and had been raining throughout most of the night. It was the fact of her having been left for so long in an open field, under such conditions, that eventually ensured the young woman's death. Hoping that they might be able to save her, Leonard Bailey, one of the two Home Guards, covered her over with his greatcoat, while the other, George Tilbury, sped to the nearby Richmond Arms from where he could telephone through to the police and also summon an ambulance. Within a short time, a patrol car had arrived, with Police Constable Hughes and Detective Constable Evans making an immediate appraisal of the scene. They noted the various injuries that the woman had sustained, these not only including a blow to the back of the head, but also blackened eyes and an incised wound on her chest. Serving as a possible motive for the attack, the woman also had dishevelled clothing, the stocking on her left leg down over an ankle while an upper under garment had been torn open. The ambulance was only a short time behind the arrival of the two policemen, with the victim of the attack being immediately taken to the Royal West Sussex Hospital.

The fact that the victim, twenty-two-year-old Marguerite Beatrice Burge, had been left in the field for over eighteen hours sealed her fate. While the various

The same field as it appears today.

injuries she had sustained might well have been survivable, her exposure to the elements in such a weakened condition prevented any real hope that she would recover. Extremely cold and failing to recover consciousness, she died on the operating table later that same evening, the hospital surgeon attempting to relieve a build up of pressure on her brain.

About an hour prior to the gruesome discovery made by the two Home Guard recruits, two other soldiers had actually been in the immediate vicinity of Marguerite Burge's rapidly weakening body. They, however, had chosen to ignore her, considering her to be already dead. If they had acted in the same way as Bailey and Tilbury, they might well have saved her life. After all, as it was sternly pointed out to one of these two men when appearing in court, 'an hour makes a big difference when it is a question of saving or losing a life'.

These two soldiers were Privates Charles Raymond and Arthur Patry, both French-speaking and members of the Royal Canadian Army Service Corps, who had arrived in England a few months earlier. As with Thomas Flack, both were lorry drivers, each being in charge of a three-ton Chevrolet truck. In not reporting the discovery, both claimed that they simply did not want to get into trouble with the police. An extremely callous response, given that

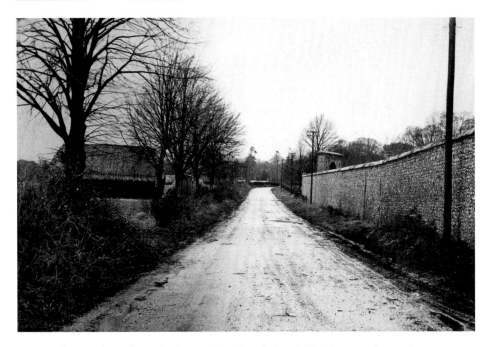

A general view along the Halnaker to Waterbeach Road. This is one of several photographs taken by the county constabulary at the time of the police investigation into the murder. (National Archives, MEPO3/2247)

they had no certainty as to her not being alive, although both of them did have reasons for avoiding the police. In the case of Patry, it was because of a previous arrest in Canada. But for Raymond it was much more sinister – he was the woman's killer. During the previous afternoon, while driving his truck back from Chichester, he had come across Burge while she had been walking along the main road towards Halnaker. Offering her a lift, which she seems to have accepted, they drove the short distance to Halnaker before taking the by-way to Waterbeach. It was on this lonely country lane, not far from Raymond's billet on the Goodwood Estate, that he attacked the young woman before dragging her into the field. Here he left Marguerite Burge to die, her body partly concealed by a perimeter hedge. Patry knew none of this, nor that he was to be dragged into the affair, deliberately implicated by Raymond.

Raymond's return journey to the field began with a Sunday morning conversation in which he invited Patry to join him for a drink at the Richmond Arms. 'I have no money,' Patry responded. 'Don't worry, I have got some,' replied Raymond encouragingly. While walking in the general

The Richmond Arms. It was from here that George Tilbury phoned the police shortly after he, and a fellow member of the Home Guard, had found the dying woman.

direction of the Richmond Arms, Raymond made a suggestion that they should go instead to the Anglesey Arms. In doing so, he ensured that the two men would walk directly past the field where he had attacked Marguerite Burge. 'Let's go to the other pub,' he suggested. 'A woman told me they open earlier on a Sunday.'

Now walking in the direction of Halnaker, they approached the field. 'There's something behind that hedge,' Raymond proclaimed as he came to a sudden stop. 'I can't see anything,' Patry responded as he also peered into the field. 'There is something,' reiterated Raymond. 'There's a girl behind the hedge.'

The two of them entered the field, with Patry seeing what he first thought was a man but as he got nearer, realised it was a woman in Royal Air Force uniform. Going no nearer the body than a distance of 10 ft he concluded, so he claimed, that she was already dead. 'Let's go,' he suggested to Raymond. 'I don't want to get into trouble with the police.'

Abandoning Marguerite Burge at a time when her life was in the balance, the two men continued their leisurely walk to the Anglesey Arms. Here, Patry duly received the drink that Raymond had promised him. It appears they remained there for twenty minutes before returning to camp.

The Anglesey Arms. It was here that Raymond and Patry went for a quiet drink after failing to report that they had also discovered Marguerite Burge lying in the field.

That Raymond was eventually caught was the result of painstaking police work that was overseen by two senior Scotland Yard officers. While the enquiry, in its first few hours, had been placed in the hands of Chichester's two leading detectives, Superintendent Savage and Detective Inspector Widdicombe, the chief constable was also aware that his own force fundamentally lacked the necessary expertise. As a result not a moment was lost in requesting help from the Yard, with Detective Chief Inspector Thomas Barratt and Detective Sergeant Charles Morris appearing on the scene less than twenty-four hours after the discovery of the body. Also brought into the enquiry was Sir Bernard Spilsbury.

Over the next few days, several people came forward who had either seen the uniformed WAAF on the day she was attacked or had seen an army truck in the vicinity of the field. From these various individuals it was possible to work out how Marguerite Burge had spent the last few hours of her life. According to Clare Berry, one of her friends in the WAAF, she had seen Marguerite leave Tangmere airfield shortly before 1 pm on the Saturday. She was on her way to Boxgrove where she had a date to meet Stanley Clarke, a sergeant in the Army Physical Training Corps. They had first met a couple of days earlier in Bognor and this was to be their first outing alone. However, there must have been a

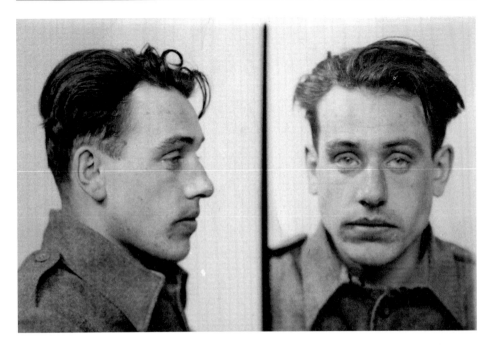

Private Charles Raymond, the murderer of Marguerite Burge. (National Archives, MEPO3/2247)

misunderstanding on the part of one of them, with Clarke waiting for fifteen minutes at Boxgrove corner and the young WAAF at the nearby Strettington cross roads. George Hardwick of the RAF Regiment brought this last piece of evidence to the police. He was also at the Strettington crossroads waiting for the Bognor bus. She, at the time, was sitting on a nearby wall and they fell into conversation. The bus being late resulted in the two of them talking for about thirty minutes.

Leslie Boxall and Frank Goff, both living at the Halnaker end of the lane that leads to Waterbeach, saw the young WAAF that same afternoon. At the time they were both looking out towards a nearby copse where there was a pheasant shoot when they happened to see her at around 3.50 pm. At the time, and they seemed fairly convinced it was Marguerite Burge, she was leaning into the doorway of an army vehicle that was about 300 yds away. She appeared to be talking to the driver. While they did not see her get into the lorry, the same vehicle passed them by and in the cab they could see both a soldier and a WAAF. The lorry remained within sight, pulling up at a copse known as Inkpen Firs where it remained for nearly a quarter of an hour. It then continued along the lane towards Waterbeach where they lost sight of its progress.

The murdered WAAF.
(National Archives, MEPO3/2247)

Another witness who came forward was Alfred Horner of Waterbeach Lodge. Leaving home at about 4.15 pm to cycle to Boxgrove, he saw an army lorry parked next to the field where the body was later found. Standing by the cab door was a soldier. When the soldier saw the cyclist he quickly disappeared behind the vehicle and reappeared with some papers in his hands. As Horner cycled past, the soldier made a point of looking at these, rather than showing his face.

Other witnesses also confirmed having seen a military vehicle in the area and being parked alongside the field. As a result, the two Scotland Yard detectives felt confident in directing their enquiries towards men based at the various army encampments around Chichester. However, this was easier said than done. At that time there were approximately 40,000 troops stationed near Chichester. Furthermore, many of them were difficult to contact, with some engaged in practice manoeuvres and others on leave, while a sizeable number had simply deserted.

For the police enquiry based in Chichester, the task of making contact with these thousands of soldiers would have proved impossible without the assistance given by the military itself. A number of 'red caps' were ordered to support the enquiry, carrying out numerous interviews on behalf of the local constabulary.

In particular, help given by Sergeant Joseph Raoul Carreiere of the Canadian Provost Corps proved indispensable. Conducting interviews among the various French Canadians based around Chichester, he eventually came upon Private Charles Raymond. This was at the Goodwood camp on 9 February with the interview conducted entirely in French. On that occasion, nothing particularly dramatic emerged, Raymond merely claiming that on the day the WAAF was attacked, he only went out of camp during the morning and spent the rest of the day working on his truck. When a photograph of the dead girl was shown to him, he denied having ever seen her.

The point of all these interviews was to check that accounts given by one soldier tallied with those given by others. A few days later, in cross checking various notes, Detective Chief Inspector Barratt became aware that Raymond might not have been telling the truth. Notes made of other soldiers interviewed showed that Raymond had most certainly been on the road that same afternoon. At least two soldiers reported that he had given them lifts into Chichester. In addition, receipts from a petrol station in Lavant showed that he had refuelled the lorry sometime around 3 pm. Given that Lavant was only a few minutes drive from where the WAAF was last seen, this ensured that Raymond was very much in the frame.

On 24 February, Provost Sergeant Carreiere once more interviewed Raymond, this time asking him why he had lied at the previous interview. His answer was both dramatic and stunning. 'I will tell you everything, Patry is your man,' he suddenly proclaimed. 'I was with him when we discovered the WAAF at 11.20 am on Sunday 31 January.' Immediately taken into the police station to make a full statement, he began to make a series of incredible charges against his former drinking companion. To begin with these were fairly simplistic, stating that Patry must have killed her because he heard him talking in his sleep, calling out about WAAFs and detectives. Although they shared a common sleeping area with a number of other men, nobody else had heard Patry talking in his sleep. However, as his thoughts developed, Raymond began to make a series of more substantial allegations. Admitting that he had taken soldiers into Chichester that same afternoon and had 'gassed up' his lorry on the way back, he also admitted to stopping next to the field where the murder had taken place. According to his statement:

While driving back along the Halnaker Waterbeach road I saw Patry's truck ahead of me and I saw it pull up just after I saw a WAAF girl in the road.

The truck driven by Charles Raymond and in which he admitted giving a lift to the young WAAF. (National Archives, MEPO3/2247)

Adding, however, to the confusion and so helping undermine his increasingly complex tale, was that he now claimed that he had actually seen the woman inside Patry's truck. Either way, his original statement continued,

> I passed Patry's car and stopped. Walking back I saw Patry and the girl in the field. Patry was kneeling beside her. The girl fell and when I entered the field Patry was kneeling beside her. 'What are you doing with that girl,' I asked. Patry told me to clear off and mind my own business. I saw that Patry had a knife and he then grabbed my sweater and began to kick me. I ran to my lorry and returned to camp.

However, two problems existed with this statement. Enquiries already made clearly indicated that Patry was nowhere near Halnaker on the afternoon of the murder. As it happens, he had been given an assignment that had taken him to Scotland and was not to return to camp until 11 am on the Sunday. This was something that Raymond failed to take into account. The second problem was that of the several witnesses who had reported seeing a military lorry in the area, none had reported seeing two.

A further view of the same truck, taken at the time forensic evidence was being collected. (National Archives, MEPO3/2247)

On 4 March, Raymond was formerly arrested. As a result, his accusations against Patry intensified. This time he blurted out that Patry had killed her with a screwdriver. While he was correct about the murder weapon, it was not something that the police had admitted in public. In other words, Raymond knew too much about the murder and was simply providing further evidence that pointed to his own involvement.

Other evidence was also accumulating against Raymond. Not least was an increasing amount of forensic evidence. Once again, the local constabulary had made use of the forensic laboratory at Hendon with Dr James Davidson again playing a key role. Of particular significance was that of a grey balaclava hat found at the scene of the crime and being found to contain hair belonging to Raymond. In addition, lipstick marks on Raymond's tunic were found to match that worn by Marguerite Burge.

Once again, in being presented with this evidence, Raymond tried to link it to Patry, stating that the balaclava helmet was actually the property of Patry. He recognised it, so he claimed, because of certain holes that it contained.

Later, at his trial, it was pointed out that these holes had actually been made during tests at the forensic laboratory in Hendon.

Following various appearances in the Chichester Police Courts, Raymond was finally brought to trial at the Old Bailey in May 1943. The evidence presented for his defence was most unconvincing with the jury only retiring for twenty minutes. On being told that the jury had found him guilty, he merely responded in French by denying his guilt. His appeal, heard on 22 June, was similarly dismissed through lack of any convincing evidence. However, prior to his execution at Wandsworth Prison on 10 July 1943, there was one further twist in the tale. Having finally realised that he could not pin the murder on Patry, Raymond now produced an entirely new story and one that has never previously been made public. Instead of denying his guilt, Raymond now admitted to the murder – but claimed it was the result of a fit of passion brought about by Marguerite Burge's own behaviour.

It seems that Raymond was now seeking mercy for his action by claiming that Burge had been his girlfriend and that they had been having a long-term affair. As such, their meeting had been pre-arranged with her agreeing to enter the field for amorous reasons. During the preliminaries to a period of love-making, so Raymond claimed, he had become aware of the WAAF being unfaithful, even though he had paid her money to keep away from other men. In a letter addressed to the Home Secretary he embellished this highly fictional account by a possible true version of what had really happened on the field at Halnaker,

> She gave me a slap on the face. I slapped her with my fist under the jaw. She fell on the blades of a plough. She lost consciousness. There I killed her. I do not remember how. I had my screwdriver that is all I remember... I completely lost my head.

A full enquiry to determine the truthfulness of these latest revelations was immediately ordered. In particular, further interviews were carried out with those who had known Marguerite Burge, her former friends being asked if she had ever mentioned a relationship with a Canadian soldier. All denied that she had ever mentioned such a relationship and were united in their belief of her having been a 'clean living girl of the highest morals'. In addition, her diary and private letters were also examined, these also confirming that she had never previously known Raymond.

Richard Phillips, the chief constable of the West Sussex Constabulary, on hearing of Raymond's attempt to place the burden of guilt on his innocent

victim was quite incensed. He described Raymond as having the cunning of an animal that, in his attempt to escape the noose, was prepared to implicate any and everyone, regardless of who they might be. That Burge should have her good name protected was something that he was determined to do. As such, he rested happily on the evening of 10 July, knowing that Raymond was no longer in a position to implicate anyone else in his devious and horrific crime.

Chichester's two leading crime fighters, Savage and Widdicombe, had also been involved in a double murder enquiry one year earlier. On this occasion the scene of the crime was Bognor, with the station at Chichester used to co-ordinate the various efforts that led to a successful conviction. Once again the local constabulary found itself looking for a soldier – this time a deserter who had armed himself with a stolen pistol.

This was yet one more crime that would not have taken place if the country had been at peace. The man they were looking for was Private John Moore, an absconder from the Canadian Highland Light Infantry. While under close arrest at the regiment's headquarters building, in reality the Arlington Hotel in Aldwick Road, Moore managed to escape. Before leaving the building he broke into an ammunition store, supposedly secure as it stood next to the guardroom, and took a .22 pistol with 700 rounds. This was on Sunday 15 February 1942, and over the next few days the deserter went on a local housebreaking spree. Primarily he was after food and somewhere to rest up; but he also stole a radio, money and various items of clothing. Most of the premises he entered were in the Aldwick area, his entry made easier by several of the houses being left by their owners who were away on war service.

One particular house, 16 Fernhurst Gardens, proved particularly attractive to Moore. Its owner, Joseph Ghinn, then attached to a non-combatant corps, had acquired the house as a holiday home. In leaving it unoccupied he had left it in a fully furnished state, with electricity and abundant heating. Furthermore, there was a stock of tinned food stored in the kitchen. Guessing that the owner would probably not be returning for several weeks, Moore decided to remain there for as long as possible. However, he had left one clue as to his entry, a broken side window.

It was the window that attracted the attention of Francis Fuller, a contract gardener who was also employed by the owner of number sixteen to keep an eye on his property. On seeing that the house may have been broken into, Fuller called the police. It was now Thursday 26 February, with Police Sergeant William Avis, who had been in charge of investigating this spate of break-ins, arriving on his pedal bike sometime around midday. The gardener, who had

The house in Fernhurst Gardens where the fatal shooting of PC William Avis took place.

a key to the house, took Avis to the main door, which was to the side of the house, and unlocked it for the purpose of gaining entry.

As the door opened Moore, who was standing in the hallway, confronted the two men. The police sergeant immediately moved forward and at that point probably realized that the intruder was pointing a gun at him.

Not surprisingly, the arrival of a policeman had attracted a small amount of attention in the road, a few people twitching their curtains, while others looked up from tending their wartime-only front garden vegetable patches. Several were, therefore, in a position to report on the events that now followed, given that Avis and Fuller were both about to have their lives extinguished. One of these on-lookers, Henry Shepherd, an immediate neighbour, was separated from events by a short privet hedge. He distinctly remembered Avis, upon the door being unlocked, using the words, 'come along'. Almost immediately Shepherd heard a shot fired and saw Avis fall to the ground. Fuller, not surprisingly, quickly took to his heels but found himself pursued by the deserter. Rushing down the concrete pathway towards the gate, he slipped and fell. All this was still in view of Shepherd, but when Moore saw the neighbour he pointed the gun at him. Fuller quickly ducked behind the hedge, jumping up a few seconds later when he judged it to be safe. To his horror, Sheperd now saw that Moore

had drawn level with Fuller, who was still on the ground, and proceeded to fire one bullet into his head. While Shepherd ran back to his own house to call the police, Moore retraced his steps, reaching the wounded policeman. Without a moment of apparent remorse, he again fired his gun, the bullet entering the head. Avis was now dead while Fuller, seriously injured, would die several days later without regaining consciousness.

Moore immediately fled; making his was to the local railway station, where he bought a third class ticket to London. Following a massive police search, Moore was arrested twenty-four hours later in South Mimms. His departure had been without any outward signs of panic, the soldier walking to Barrack Lane where he simply caught a bus for the station. It was, as much as anything, a result of good fortune that Moore was arrested so quickly. Although his description had been nationally circulated, it was only the result of Moore asking a plain clothed policeman, Sergeant Potter of the Metropolitan S division, for directions that he was apprehended. In being asked to produce his national identity card he failed to do so, proffering a stolen one that carried the name of a female. Potter immediately questioned this and attempted to make an arrest. In response, Moore pulled out his gun and thrust it into Potter's stomach. Fortunately, with other police officers in close proximity, the news of Potter's predicament was soon relayed to South Mimms police station. The result being that several armed police officers soon arrived on the scene and Moore was successfully arrested. The danger into which a number of officers had been placed was duly noted, with Potter receiving the King's Police Medal for Bravery.

Although Moore was arrested in Hertfordshire, his whereabouts in the hours immediately after the shooting were completely unknown. Initially, therefore, the massive search that was organised by Superintendent Savage from his headquarters at Chichester concentrated on a 20-mile area around Bognor. Involving not just the police but also the regular army and Home Guard. With many of the searchers armed it was described by one national newspaper as 'the most intensive and expensive manhunt which has ever occurred in this country'. The local *Chichester Observer* was certainly impressed by efforts undertaken, commenting on the number of men who poured into the city once the search had been called off,

Early in the afternoon it became known that a man had been apprehended in Hertfordshire, and the calling in of the many police officers, regular and special, and of military units that had been concerned in the hunt, created quite a stir in the city, as they arrived from various directions.

It was Inspector Widdicombe who was charged with the responsibility of bringing the prisoner back to Chichester and then formerly charging him with the murder of Police Sergeant Avis. Already Moore had admitted to gunning down both Avis and Fuller and had been warned by Widdicombe that he would be asked to make a full statement. At no point, in fact, did Moore attempt to conceal his guilt, saying to Widdicombe on their first meeting, 'I admit it; I'll make a full statement when I get back'.

And Moore was true to his word, providing a full account of all his activities over the past weeks. At no time did he show any remorse, seemingly detached from the horrific actions he had taken on that Thursday afternoon in Aldwick,

> [Police Sergeant Avis and Francis Fuller] came round to the side door and I heard a key rattle in the lock. They opened the door and I approached them with a revolver. I told them to get back. The gardener turned and ran round to the front of the house. The sergeant took off his gloves. He made a lunge at me and seized the revolver with his left hand and my left arm with his right. In the ensuing struggle the revolver went off and the sergeant fell to the floor. Then, becoming excited, I ran after the gardener, took a shot at him and he fell to the ground. Re-entering the house I must have taken another shot at the sergeant while he was lying on the floor.

Following a period of remand at Lewes prison, Moore was tried at the Central Criminal Court at the Old Bailey in mid-April 1942. While a verdict of guilty was an inevitable outcome, Moore did avoid an appointment with the public hangman. His defence – that of insanity – was accepted, and Moore was condemned to a lifetime of incarceration within the Broadmoor Mental Asylum.

MUCH ADO

A short prologue is necessary here: the main off-stage character is Lionel 'Buster' Crabb. Before the action begins, he has already disappeared. This took place in the mist-covered waters of Portsmouth Harbour early on the morning of 19 April 1956. A highly experienced naval frogman, Crabb had been diving in the near-vicinity of *Ordzhonikidze*, a visiting Soviet warship. We now know that he was playing out the role of spy, employed by MI6 to survey the underwater hull of this advanced and highly secret warship.

It was a seriously bungled operation, neither sanctioned by the government nor particularly well organised. With Crabb failing to return from his mission, Sir John Alexander Sinclair, Chief of MI6, found himself placed in a highly embarrassing situation. No longer could this unauthorised action remain secret. To extract himself from this quagmire into which he had fallen, Sinclair simply entered into a state of total denial. As for Prime Minister Anthony Eden, Sinclair's paymaster, he was absolutely livid. In no way could he support the actions taken by the intelligence service, choosing to distance himself from what was clearly regarded as an illegal operation. Speaking to a packed House of Commons, Eden chose his words carefully, but his intent was beyond misinterpretation,

> It would not be in the public interest to disclose the circumstances in which Commander Crabb is presumed to have met his death. While it is the practice for ministers to accept responsibility, I think it is necessary in the special circumstances of this case to make it clear that what was done was done without the authority or knowledge of Her Majesty's ministers. Appropriate disciplinary steps are being taken.

Although pressed by Hugh Gaitskell, leader of the Opposition, he refused to add anything further. In doing so, Gaitskell clearly warned, it could only lead

to one irrefutable conclusion, 'that an officer of Her Majesty's forces was engaged on the business of espionage during the Russian visit'. Eden replied that his questioner was 'perfectly entitled to put any wording he likes upon what I have said'.

In this brief exchange of words, the secret was out. Crabb had, without a shadow of doubt, disappeared while engaged on a Cold War spying mission in home waters. An act of extreme discourtesy, for the *Ordzhonikidze* was present in Portsmouth as part of a state visit, it was also to provide a stick with which the Opposition could frequently return when it wished to beat the government. As for the disciplinary action to which Eden had referred, he was as good as his word, Sinclair being forced to tender his eagerly accepted resignation.

Some fourteen months later, with the eyes of the world now turned on Chichester, the whole sorry affair was once again forced on to the front page of every newspaper in the country. The point of focus was the in-session local coroner's court that was in the process of determining the identity of a decomposed corpse. Dredged out of the harbour waters close to Thorney Island, it was the body of a man clad in a black rubber frogman's suit.

Assumptions were quickly made. Could it be Commander Crabb? Since his disappearance there had been considerable speculation as to what might have become of him. Had he been killed? Had he been captured? Had he, in reality, been working for the Russians? Had he simply drowned? With the possibility of Commander Crabb's body being found, uncertainty and speculation would become undeniable reality. Where the story might lead was now anyone's guess. This was why the world's media now awaited the findings of the Chichester coroner, a man who now, if only temporarily, had greatness thrust upon him.

Act one of this impenetrable mystery took place in Portsmouth Harbour. Act two switches to the shallower waters of Chichester Harbour. The date: Sunday 9 June 1957. A warm and pleasant morning. Two friends accompany local boat owner, John Randall of Cut Mill in Chidham, on a short fishing expedition. From Bosham, where the boat had been moored, they head south into the main estuary. On one side of the boat lies Thorney Island, a Royal Air Force base with a permanently on-call Search and Rescue helicopter squadron. Eventually, as the day wears on, they reach the southern tip of Thorney, drawing level with Pilsey Island.

Lights, camera, action: about thirty metres from the small boat a black object is to be seen floating in the water. It bobs on the running tide. At one moment it is clearly visible, but in the next obscured by a passing wave. Randall manoeuvres the boat a little closer but none on board can determine the nature of the object. They begin circling, unclear as to what they had

Pilsey Island where the supposed body of Commander Crabb was washed up some fourteen months after the naval frogman had disappeared.

glimpsed. Debating amongst themselves one suggests it might be an old wartime mine while another suggests a drifting buoy. They draw closer. As they do so, two ridges become distinctly visible. Randall hints at the possibility that it might be an old tractor tyre – but he's not convinced. The boat moves even closer and one of those on board stretches out with a boat hook. Immediately everything becomes clear. It is the body – or rather the partial body – of a man in a rubber wet suit. The ridges that they had seen turned out to be the ribs of the waistband.

The rest of the day quickly plays out. The body is towed across to Thorney Island where the discovery is handed over to a hurriedly summoned air force officer. Once he has made a note of their various addresses, Randall and his two friends are allowed to continue on their way. Later that evening, Police Constable Ronald Williams calls at Cut Mill and takes a more detailed statement that Randall agrees and signs. Williams had already inspected the body for himself, a fact that he later recorded,

I was stationed at Southbourne. At about noon on 9 June, I went to the Royal Air Force station at Thorney Island and accompanied the station medical officer

to Pilsey Island. On the beach I saw some human remains. They were part of a body of a man dressed in a black rubber frogman's suit. The head and the upper part of the body, and the arms were missing.

Yes, 'the head and the upper part of the body, and the arms were missing'. It is a point worth emphasizing, as Randall and his two friends had rescued from Chichester Harbour a body custom-made for the purpose of defying easy recognition. As for the soon up-and-running media scrum – the find was a dream come true. Any reporter with the smallest morsel of an imagination was quickly assigned to the story, assured of a solid by-line upon any hint of a new angle.

Enter Police Superintendent Alan Hoare. A senior member of the Chichester force, he thoughtfully manages to fuel the emerging speculation as to the possible identity of the headless corpse. As if wishing to see his name in lights, he mumbles the name for which all were waiting impatiently to hear, that of the mysterious Commander Crabb. Admittedly, his lines were not the greatest ever written, but they certainly captivated the audience. For the benefit of the press, he iced their cake with a few words spoken in that strange official style that is the policeman's lot, 'account must be given to a strong assumption that the body is that of Commander Crabb'. The cat, or maybe even the mole, was out of the bag.

To secure his temporary centre stage role, the superintendent had a few pieces of supporting evidence. Having previously spoken to the coroner, he already knew that the body showed the necessary signs of having been immersed in seawater for several months. In making enquiries along the coastline from Kent to Cornwall, he was also aware that no other similarly clad frogman had been reported missing for at least two years. So, it was reasoned, there existed a strong assumption.

Act three. Chichester Magistrates Court, Southgate, Tuesday 11 June. With the public gallery totally in the hands of the media scrum, the inquest is opened on the body of 'an unidentified man'. It proves a disappointing scene, adjourned almost as soon as it has begun. The only witness present, Police Constable D. Castleden, officer to the coroner, answers a few brief questions. These relate to nothing more than what the unidentified man had been wearing. It transpires that under the black rubber frogman's suit he had been wearing maroon coloured swimming trunks, blue woollen combinations and a pair of blue socks. Briefly, the scene is enlivened just prior to curtain fall by the desperate actions of exiting reporters. With flaying elbows and broadened shoulders, each is determined to commandeer the nearest phone that will place them in touch with a Fleet Street news desk.

The Royal West Sussex Hospital where, on 10 June 1957, an examination was undertaken on the body of the unknown frogman.

Here a brief flashback scene. The curtain rises on the public mortuary room within the grounds of the Royal West Sussex Hospital. It is Monday 10 June. Local pathologist Dr Donald King has just completed a sixty-five minute examination of the body that had been received in to the mortuary that previous evening. Unhurriedly, he writes up his findings, aware that every word will be devoured by a soon to be assembled audience.

Dr King begins with a description of the corpse, noting that, above the waist, 'parts of the body including the skull had disappeared'. He further adds 'that certain bones, including the left humerus and both scapula, remain'. As for the various organs, 'these have undergone extensive post mortem change, including a change known as adipocere'. Nevertheless, 'they are still recognisable'. For purposes of identifying the body, Dr King also provides a description of a few distinguishing features that might help in this task. He estimates the overall height to be of about 5 ft 6 in while the feet are decidedly small for an adult man. Turning to the colour of hair as found on the remaining parts of the body, 'the pubic hair is intact and the colour clearly a light brown and in certain lights when dry it had a gingerish tinge'. As for the legs these are 'in a good state of preservation and I would describe them as being muscular and well formed. They are quite straight'.

Act three, scene two, takes place in Bognor. The old public mortuary in Chichester lacks a refrigerated zone and is of little value for a retained corpse. It is to here that Margaret Elaine Crabb has been invited. As Crabb's former wife – they were divorced in December 1954 – she has been asked to view the body. Despite the couple having only lived together for a year, she was considered the best prospect for a definite identification. In a session of the Coroner's Court that was resumed on 26 June, she was to provide a description of Crabb that bore a close resemblance to the one of the corpse already provided by Dr King, she described her former husband as a short man, 'he was not as tall as me,' she stated. 'And how tall are you?' asked the Coroner.

'My height is five feet five inches.' 'Will you continue describing your husband?' 'His legs were very straight and muscular and the hair on his body was very light brown inclined to ginger. His feet were small and his big toe was very unusual. They appeared to be what I thought were hammertoes and were raised high off the ground. I think he took a size six shoe.'

However, Margaret Crabb, while attending the Bognor public mortuary failed to confirm the unidentified man to be that of her husband. While she agreed that there were many features in common with her husband, the feet appeared very different. The body she viewed appeared not to possess the same hammertoe appearance about which she was so adamant. As for those reporters who had been present at the coroner's court, it was this latest revelation that caught their attention. After all, only on the fashion pages could they run a lead story headlined, 'unidentified man wears maroon underwear'.

Act four: signs of frantic activity. For once the various cloak-and-dagger agencies are seen to be working in harmony. MI6, having orchestrated a massive intelligence gathering disaster, has successfully entangled the Admiralty's own undercover department in the matter. Primary aim: bring the entire business to a quick and sudden termination. How? Ensure that the court at Chichester identifies the body pulled out of the water as that of Commander Crabb. If there are no further revelations then the whole episode will soon be forgotten.

And it was important that no further questions should be asked at that stage. While 'six' might have overseen the spying mission operated by Crabb, it has been more recently revealed that the Admiralty had their own little secret that they desperately needed to hide. Rear-Admiral Sir John Inglis, director of naval intelligence and working alongside MI5, had sanctioned a separate spying mission to uncover the secrets of *Ordzhonikidze*. Undertaken by four naval divers attached to HMS *Vernon*, a naval shore establishment on Portsmouth's Whale Island, one of their number had also gone missing. Unlike Crabb's well-

Brief issued by CNI to concern Crabb Hall ?.

1064

(1)

B R I E F

Copies to:

News Room Private Office
Duty Commander Resident Clerk

Cdr. L.K.P. Crabb, OBE,, GM,, RNVR,, who was specially employed in connexion with trials of certain underwater apparatus, has not returned from a test dive and must be presumed drowned.

2. The above is NOT to be volunteered to the Press, but can be used in answer to any pertinent Press enquiry which may arise.

3. If pressed by the enquirer, it can be admitted that the location was in Stokes Bay, Portsmouth area.

4. Similarly, if pressed, it is to be admitted that he became missing, presumed drowned, on 19th April.

Part of a secret briefing document issued by naval intelligence for the purpose of deliberately confusing the media over events surrounding the discovery of the unknown frogman.

publicised disappearance, this second mishap had been kept successfully away from both the public and politicians.

If the body discovered in Chichester Harbour was not that of Crabb, then it stood a good chance of being the missing man from the diving team sanctioned by Inglis. If Prime Minister Eden had been angry when he learnt of the MI6 mission, he was hardly likely to be any more forgiving about a second unsanctioned dive. So, in order to allow the Admiralty's well-kept secret to remain a well-kept secret, then it was absolutely essential that the unidentified body be quickly identified as that of Commander Crabb. And that, undoubtedly, was the real reason why senior naval intelligence operatives so carefully courted the Chichester coroner. Now, even Len Deighton or Ian Fleming would be hard put to come up with a more intricate or complex plot line.

In ensuring that the body was to be identified as that of Crabb, one immediate problem still had to be overcome. Margaret Crabb's failure to identify the body was already in the public domain. On the morning of 10 June, one establishment newspaper, the *Daily Telegraph*, was reporting,

Mrs Crabb, former wife of Lionel Crabb, the naval frogman, failed to identify the body found off Pilsey Island, Chichester, on Sunday, as that of her ex-husband.

The newspaper further informed its readers,

The failure of Mrs Crabb to make any identification means that apart from clothing, the burden will rest on scientific tests and measurements. Unless the clothing is positively identified or fresh evidence is forthcoming, the body may never be recognised by the authorities as that of Commander Crabb.

And this is where the fiendish cunning of these undercover agencies kicks in – they found someone else to identify the body. And this time they found someone who could be fully relied upon to provide the required answer.

Enter stage left, Sidney James Knowles, a former Royal Navy First Class Stoker. From 1941 through to 1945, Knowles had worked closely with Crabb on underwater work. More pertinently, Knowles was prepared to testify that he had often seen Crabb stripped in preparation for a dive. This allowed Knowles to confirm that Crabb had, in common with the corpse, ginger body hair and strong legs with large calves. However, and of far greater importance for that of connecting the body with that of Crabb, was that of Knowles indicating that he had a small scar on his leg. It was, Knowles further claimed, the exact same size and shape as that shown to him in a photo.

At the coroner's court, which reassembled at Chichester at 3 pm on Wednesday 26 June, Knowles was to play a starring role. The main witness brought in to identify the body he proceeded to confirm the similarity of the scar and went on to explain how Crabb had gained it.

'In the winter of 1945 we were serving in Leghorn,' Knowles explained. 'At that time ships in harbour had rolls of barbed wire below their watermarks for protection against Italian frogmen. Early one morning, the two of us were going to investigate the American ship *John Harrison* to see that mines were not present. As we went down, a tug came along cutting up a wash and it threw both of us against the barbed wire of the ship. When we went back to our launch I noticed that Commander Crabb had sustained a wound on the side of his left leg.'

Knowles further told the court of how he had dressed the wound and that about three weeks later he saw that it had developed into a scar. According to Knowles, 'it was in the shape of an inverted Y and about the size of a shilling'.

The only problem with Knowles' evidence, which was taken as more or less conclusive for the identification of the body, is that he was not being totally

A number of sensational accounts have been written about Crabb's disappearance. In 1968, J. Bernard Hutton wrote Commander Crabb is Alive *and in which Hutton claims that Commander Crabb had been kidnapped and taken to the Soviet Union.*

truthful. In later years, Knowles admitted that he somewhat embroidered his account, this, so he claimed, was to help the government out of a difficult situation. What prompted him to do this might well have been a brief meeting with a naval intelligence operative. In the meantime, it worked a treat. MI6 was slowly being dug out of the hole that it had deftly created for itself.

In fact Knowles and his new friends from the naval intelligence service were taking an incredible risk. On the shelves of any good bookshop was a recently published biography of Commander Crabb. It certainly confirmed that Knowles was a close comrade of Crabb but the book also made something else quite clear. Throughout that winter period at Leghorn, Commander Crabb had been unwell and had not been involved in underwater activities. At the very time that Knowles claimed Crabb was investigating the hulls of American ships, he was, as it happened, in hospital. As Crabb's biographer put it, Crabb called upon the naval surgeon and said, 'I have the most improbable complaint... actually it's piles'.

Recently released documents held in the National Archives at Kew reveal the close involvement of the director of naval intelligence in producing the necessary evidence that would result in the determination of the body being that of Commander Crabb. Within hours of their realization that Margaret Crabb might not be prepared to give the evidence they required, the chief of naval intelligence oversaw arrangements for a secret meeting between members of his department and both Superintendent Simmons and George Bridgman, the Chichester coroner. The latter, in particular, promised to bring the proceedings to a close as quickly as possible and not call into his court any senior naval officers. All this was to ensure that no questions would be raised as to the work Crabb had been engaged in on the day of his disappearance.

In a top secret naval intelligence memorandum, G. C. B. Dodds, a senior official in the department, made it clear that Knowles would provide the necessary evidence to identify the body and that carefully doctored service records would also show that, at the time of his disappearance, Crabb was not actually a serving member of the navy. According to Dodds, 'that will make the press very angry and they will give us a very bad time'. However, once the body had been identified and the court proceedings had closed, 'we can relapse into our old attitude of refusing to add anything to the Prime Minister's statement. This will not make us popular but it cannot actually do any harm'.

Of particular interest is that this same memorandum gives a synopsis of the evidence that Knowles was planning to provide. It read very differently to the evidence actually given. To the court in Chichester, Knowles stated that the scar had resulted from accidental entanglement with barbed wire that protected

the hull of a ship lying off Leghorn. In the original version agreed with naval intelligence, Knowles was to have said that the scar had resulted from a bullet wound received in the Middle East in 1944. Presumably, in the intervening few days somebody had come across Crabb's biography, and noted that Crabb had never actually been to the Middle East. Of course, if they had read the entire book, they would also have had to have radically revised the Leghorn barbed wire story. So much for naval intelligence!

Despite having provided a witness with a story that was as leaky as a kitchen colander, the intelligence agencies achieved their desired aim. In the final act of this incredible story of bungling espionage agents, the Chichester coroner did choose to confirm that the body was indeed that of Commander Crabb,

'I think it would be beyond all our ideas of possible coincidence if all these different things – the size of the feet, the scar, the colour of the hair, the sort of legs – if all these things were to be put down as sheer coincidence,' Bridgman ruled. 'Looking at the evidence in this case I am quite satisfied that the remains which were found in Chichester Harbour on 9 June were those of Commander Crabb.'

Of course, if the coroner had chosen to ask those embarrassing questions that he promised not to ask, he might well have come up with a very different verdict. At the very least, he might have questioned former Royal Navy Stoker Knowles just a little more carefully. While it is not necessarily claimed that the 'unidentified body' was not that of Commander Crabb, there is certainly an element of real doubt.

As for the intelligence services, they did not really achieve their object of killing the story. Indeed, with the coroner asking so few questions and getting so few answers, the story of Crabb's last dive has continued to run and run. Maybe the Russians killed him. Maybe he was captured. Maybe he was working for the Russians. And, most intriguing of all, maybe the body now buried in a Portsmouth cemetery, is not that of Commander Crabb. Not until 2057, when the final papers relating to those events are eventually released to the public, is an answer likely to be found. In the meantime, here are a few more intriguing questions. If it was the body of Commander Crabb, why did it suddenly appear in Chichester Harbour some sixteen months after Crabb's disappearance? Why was it missing both head and hands? And exactly what information was given to the Chichester coroner that resulted in his failing to ask some fundamental and basic questions of witnesses called? Maybe, in 2057, some of these questions may be answered – or, then again, maybe not.

AUTHOR'S NOTES

Chapter One: The Morning Drop

The watchman responsible for patrolling the area around the Anchor had his watch box at the Cross and patrolled an area that not only included West Street and Upper West Lane but also North Street and the North Walls. Doubtless, therefore, it would have taken Combes a good few minutes to find the watchman. Holloway, having been arrested was immediately incarcerated in the city gaol, remaining there except for his brief trial at the Guildhall until the time appointed for his execution. The Guildhall, described as standing in open grounds in the north-east quadrant of the city, still exists as a building, being the former church of an old Franciscan Friary that stands in the grounds of modern-day Priory Park.

The Morning Drop is based entirely on original source material. To add greater interest, I have taken some liberties with words spoken, but at no point do I misrepresent what happened. Where possible, I also lean on early nineteenth-century colloquial language, employing words and phrases known to the individuals concerned. Should some words appear unfamiliar to the modern-day reader I attach a glossary. Unfortunately, despite my efforts, I was unable to provide more extensive biographical background details of the characters mentioned – these, quite simply, are not available. Normally, for instance, discharge papers are available for soldiers at the National Archives (Kew) under series WO97. However, given that both Holloway and Parr died in service, with these documents only compiled for purposes of providing future pensions, no such papers would have been drawn up. Furthermore, as far as I can ascertain, no discharge papers exist for John Daly. As for William Combes, he remained the licensee of the Anchor for a number of years, before this same duty was taken over by Edward Combes (who I assume to be his son) and who, according to documents at the West Sussex Archives

Office, appears as licensee of the Anchor in the 1850s (see document MM1, 1854-1855).

My primary source materials were the broadsheet entitled *Trial, Conviction and Execution of John Holloway* and various editions of the *Sussex Advertiser* for October 1818. The former, which also contains the fabricated confessional speech, can be found at the West Sussex Archives Office. Also proving indispensable was *The 1811 Dictionary of the Vulgar Tongue* (reprinted 1994 by Senate Publishers of London; also republished in a new edition by Amberley Publishing, 2008).

Glossary of used colloquialisms:

Acorn tree	The gallows
Apple dumplin shop	Female bosom
Ale draper	Inn keeper
Bartholomew's baby	Showy or cheap manner of dressing
Basting	Beating
Boglander	Irishman
Bouncer	Lie
Broganier	Irishman
Brown Bess	A private soldier
Doxies	Females
Irish beauty	Two black eyes
Laycock	Prostitute
Light bob	Infantryman
Lobster	Name given to a soldier as a result of the colour of this uniform
Moll	Prostitute
Morning drop	The gallows
Nob	Head
Old Mr Grimm	Death
Orange lilies	The 35th Sussex Regiment of Foot

Chapter Two: 'Becky, I always loved you'

The main source for the writing of this chapter was file reference Par 206/7 held at the West Sussex Archives Office and which contains copies of statements made by witnesses called by John Ellis, the county coroner. In

addition, background details of various individuals were gleaned from the official census returns for the years 1851 (TNA HO107/1655) and 1861 (TNA RG9/630). William Cragg, the first appointed member to Westbourne of the new rural police force, probably found it difficult to be accepted in the community due to an incident that occurred in Westbourne in the first year of his appointment. In the strict enforcement of licensing laws, something with which the parish constables had rarely concerned themselves, the new rural force was sometimes a little underhand. In May 1857, Cragg and a plain-clothes officer decided to check on one of the village inns, the Nag's Head, following the time the serving of drinks should have ceased. The plain-clothes officer, not declaring who he was, knocked on the front door and asked for ale as a traveller on the road. The landlord refused to admit him. The officer then stated his real purpose but was still refused admission. However, upon the appearance of Cragg, the two were admitted and they found two men inside still drinking. The outcome was the landlord being fined ten shillings. However, the Duke of Richmond, who was chairing the court, requested that the police should, on all future occasions, clearly state their business and not attempt to use subterfuge. See the *West Sussex Gazette*, 14 May 1857.

Chapter Three: Sloe Fair or No Fair

Sources for the writing of this chapter are quite varied and included material from both the West Sussex Archive Office, the National Archives (Kew) and several newspaper titles. From the Archive Office, details relating to changes in policing were drawn from a general history of the police in Chichester (Add Ms 1635) and for a description of the new rural police station, the original drawings of the building (QAC/4/W6). From the National Archive, material relating to the work of the Guardians (MH12/12823-5), a file on the campaign to terminate the Sloe Fair (HO45/10060/B1622) and the planned move of the site of the fair (HO45/20789) were used extensively as were various day books relating to policing in Chichester (W/C 1 series). Also consulted in the Archives Office was A. J. Dyer's, *The Formation of the West Sussex Constabulary* (Hayling Island, no date) and filed as MP856. The manuscript held in the Chichester Cathedral chapter is entitled, *Curia Pavillonis Cisestriae* (L.VI, 1729).

Also used were the following:

W. Victor Cook, 'Chichester's Sloe Fair' in *Sussex County Magazine* 9 (1935), 755-7
Ken Green, *Chichester: An Illustrated History* (Derby, 2002)
Leslie Evershed-Martin, *The Impossible Theatre* (Chichester, 1971)
Emlyn Thomas, *Georgian Chichester* Volume II (Chichester, 2001)
T. G. Wills, *Records of Chichester* (Chichester, 1928)

Chapter Four: 'Oh murderer, she was the joy of my life!'

In concluding that the murderer of Vera Hoad was a long-term resident of Chichester, I have based this on the evidence associated with her abduction and location of the body when found. Whoever committed the crime must have had some knowledge of the city area. In addition, the distance between her likely place of ensnarement (most probably Northgate) and the grounds of the hospital is, approximately, one mile. At some point a motor vehicle would have been required for the purpose of securing anonymity. These were clues ignored by the local police. Supporting my main assumption, that of it being someone local, is that of evidence produced by more recent crime profilers who indicate that those who carry out similar crimes to the one described tend to operate within areas in which they are both comfortable and familiar. According to Davies and Dale (1995) about one-third of victims were approached within a mile of where the attacker lived and the vast majority within five miles.

Poole's Picture Palace, the cinema to which Charles Fogden was headed at the time he saw Vera Hoad, operated out of the Corn Exchange. In later years it was renamed the Exchange and at the end of the twentieth century was part of the MacDonald's fast food chain. Latterly it has become a dress shop for the Next chain. The Royal West Sussex Hospital gained the term 'Royal' (previously it had been the West Sussex Hospital) in 1913 following a visit to the hospital by George V.

Primary sources for the writing of this chapter included surviving case records of both the West Sussex Constabulary and the Metropolitan Police, with the latter containing a number of suppositions as to a likely suspect. These files are held respectively at the West Sussex Record Office (File: POL/WC/6/3) and The National Archives (File: MEPO3/1603). In addition, both national and local papers for the years 1924 and 1933 were consulted.

Chapter Five: 'It's very piercing cold, isn't it, mister?'

The trial of Ellen Harding, or at least her successful hearing at the Court of Criminal Appeal, was unique. As a result, the writing of this chapter was greatly helped by the massive amount of national as well as local press coverage. Particular newspapers referred to are evidenced within the text. However, considerable use was also made of the file and transcripts of her court appearances, these held at the National Archives (Kew), document reference HO144/20214. A further invaluable source was that of interviews I conducted with surviving relatives of the Harding family and who added considerably to my understanding of the underpinning social dynamics that existed between Ellen Harding and her husband. The couple were eventually divorced and the remaining children chose to have little to do with their father.

Chapter Six: Murderers and Black Marketeers

A major source for this chapter was the court reports contained in the *Chichester Observer* for the period. However, as cases sent to the Assize Court in Lewes, including those that had begun in Chichester, were less often reported in the *Observer*, additional use was made of the *West Sussex Gazette*. National newspapers, especially the London *Times*, were also of value, especially regarding Raymond and Moore. The involvement of the Metropolitan Police in some of the more high profile cases also offered a further source, that of files held at the National Archives. These included MEPO/3/2210 (Private John Moore) and MEPO/3/2247 (Private Charles Raymond). The following books were also consulted:

Douglas G. Browne, *Bernard Spilsbury: His Life and Cases* (Harrap, London, 1951)
Andrew Rose, *Lethal Witness* (Alan Sutton, Stroud, 2008)
M. J. Trow *War Crimes* (Pen and Sword, London, 2008)

Chapter Seven: Much Ado

At the time of his disappearance, Lionel 'Buster' Crabb was already a well-known name. His wartime exploit of removing limpet mines from the underwater hulls of ships in harbour had resulted in the award of the George

Medal. In later years he gained further fame with dives in connection with the loss of two naval submarines.

Even prior to his disappearance, his biography was awaiting publication, while his wartime exploits were eventually brought to an ever-wider audience through the widely distributed film *Silent Enemy* that starred Laurence Harvey in the role of Crabb. His secret spying mission to unravel the underwater secrets of the *Ordzhonikidze* was not the first such operation he had undertaken. In the autumn of 1955 he had surveyed the hull of *Sverdlov*, a Russian cruiser that had also been moored in British waters. That he had narrowly escaped detection had been generally recognised at the time. From this, the assumption must be that the Soviet navy was prepared for a further attempt to carry off its secrets when the *Ordzhonikidze* arrived at Portsmouth. Whether Crabb was captured or killed by Soviet divers protecting the secrets of *Ordzhonikidze* is just one aspect of this long running saga. In either case, the body discovered in Chichester Harbour, be it that of Crabb or a further British naval diver, is crucial to the unravelling of this story. While some answers may emerge through the release of further documents held at the National Archives, there is always the intriguing possibility of the body being exhumed and subjected to DNA tests.

That Crabb carried the tag 'Buster' relates to the similarity of his name to the 1930s swimmer and movie star 'Buster' Crabbe.

Primarily, in writing this chapter I used both recently released documents held at the National Archives (ADM1/29240) and Sussex Police records held at the West Sussex Archives Office (Pol/WC/6/2). This is the first time that these two files have been jointly used, allowing me to reach several original conclusions. I used *Hansard* for the report of the Parliamentary debate held on 14 May 1956 while a number of national newspapers (as cited in the text) proved valuable. Reference was also made to the following published books:

Don Hale, *The Final Dive* (Sutton Publishing, 2007)
J. Bernard Hutton, *Commander Crabb is Alive* (Award Books, 1968)
Marshall Pugh, *Commander Crabb* (Macmillan, 1956)

Also available from Amberley Publishing

Jack the Ripper – Case Closed
by Andrew Cook

Price: £18.99
ISBN: 978-1-84868-327-3

Available from all good bookshops or from our website
www.amberleybooks.com

Also available from Amberley Publishing

Death Ride From Fenchurch Street
and other Victorian Railway Murders
by Arthur and Mary Sellwood

Price: £12.99
ISBN: 978-1-84868-495-9

Available from all good bookshops or from our website
www.amberleybooks.com

Also available from Amberley Publishing

Norwich Murders & Misdemeanours
by Frank Meeres

Price: £12.99
ISBN: 978-1-84868-457-7

Available from all good bookshops or from our website
www.amberleybooks.com

Also available from Amberley Publishing

Victorian & Edwardian Sussex
by Aylwin Guilmant

Price: £14.99
ISBN: 978-1-84868-024-1

Available from all good bookshops or from our website
www.amberleybooks.com

Also available from Amberley Publishing

1811 Dictionary of the Vulgar Tongue

Price: £12.99
ISBN: 978-1-84868-062-3

Available from all good bookshops or from our website
www.amberleybooks.com